THE SECRET FACE OF NATURE

THE SECRET FACE OF NATURE

JÜRGEN KRÖNIG

Foreword by John Michell

GOTHIC IMAGE

PUBLICATIONS

© Jürgen Krönig 2001

All photographs © Jürgen Krönig
one photograph of author on back cover © Katharina Krönig

First published in Great Britain in 2001 by Gothic Image Publications,
PO Box 2568, Glastonbury, Somerset BA6 8XR, England.

ISBN 0 906362 55 5

A CIP catalogue record for this book is available from the British Library.

Book and cover design by Peter Woodcock
Layout by RWS Studios, Glastonbury, Somerset
Printed by Midas UK and Malta

Cover photograph: *Guarding the shore*, Costa Smeralda, Sardinia
Back cover photograph: *After the harvest*, near Beckhampton, Avebury, Wiltshire
Photograph of the author at Great Staple Tor, Dartmoor, Devon

For Katharina, who knows why.

Select Bibliography

Gould, Stephen Jay. *Time's Arrow, Time's Cycle – Myth and Metaphor in the Discovery of Geological Time*. Penguin books, 1987

Gould, Stephen Jay. *Rocks of Ages: Science and Religion in the Fullness of Life*. Jonathan Cape, 2001

Huxley, Aldous. *The Doors of Perception*. Grafton, 1977

Jung, C J. *The Archetypes and the Collective Unconciousness*. Routledge and Kegan Paul, London, 1959

Jünger, Ernst. *Subtile Jagden. Vol 10 of Sämtliche Werke*. Klett-Cotta, Stuttgart, 1980

Lawrence, D H. *Studies in American Literature*. Thomas Seltzer and Sons, New York, 1923

Lovelock, James. *Gaia: a New Look at Life on Earth*. Oxford University Press, Oxford, 1988

Mckenna, Terence. *True Hallucinations*. Harper San Francisco, 1993

Mckenna, Terence. *The Archaic Revival*. Harper San Francisco, 1991

Michell, John. *Simulacra: Faces and Figures in Nature*. Thames and Hudson, 1979

Sheldrake, Rupert. *The Rebirth of Nature: the Greening of Science and God*. Century, 1990

Swan, James A. *The Power of Place*. Quest Books, 1991

Acknowledgements

I wish to express my gratitude first and foremost to my publisher and editor Frances Howard-Gordon and to Jamie George for their generosity, patience and support. To John Michell, who introduced me to the whole topic of *Simulacra*, to the many friends who encouraged me to do this book after enduring the slide-show and not even falling asleep on It. A special thank you to Chris Hitchen and George Wingfield for sparking off ideas. And above all, to Katharina for her critical eye, her ideas and companionship.

Contents

List of photographs

Foreword

ON SEEING SIMULACRA

"You're seeing things," they say. "It's just your imagination." Sensible people talk like that, and no doubt they are right. But when you notice a rock or mountain, curiously shaped to resemble a human profile, you can hardly help drawing attention to it. It is even more striking when the face you see looks like someone you know. And best of all is when natural forms and features in the landscape remind you of the local people and wildlife. That is where mysticism breaks in.

"It is just a coincidence," say the sensible people. There again they are right, and that is why I am so attracted by 'simulacra' or spontaneous images in nature. Seen as 'coincidences', they belong to one of the most interesting of all subjects. It is rightly called 'borderline', because the first question it raises is whether or not there is any subjective value in it. Many learned people have written about coincidences, and all lively people experience them. But most of the data in this subject is trivial and apparently meaningless. You think of someone and they call or turn up, or you hear an unusual word on the radio just as your eye lights upon the same word in the paper you are looking at. That's funny, you think. But it does not lead to anything, so you forget it.

Yet some coincidences are timely and seem like an answer to prayer, or desire. Famous among writers is the 'library angel'. That was Arthur Koestler's name for the helpful spirit (or natural law) that brings to honest researchers, as if by miracle, the one book or reference they need at the time. Significant images are sometimes revealed by the same phenomenon. Here is an example. When the Armenian national hero, St Vartan, was killed by Persian invaders, his followers went to the place of his martyrdom to pray for his return. They were rewarded by his image, true to life and complete with his bishop's mitre, that appeared in the local rocks. You can see it to this day – when the sun is in the right position.

The rock-image of St Vartan was included in my book on spontaneous portraits and symbols, *Simulacra* (1979). One of its objects was to show the influence of locality, or *genius loci*, on all the natural products – human, animal, even geological – of each district. That aspect of the subject is beautifully illustrated in Jürgen Krönig's work. Walking through the wild, upland regions of Britain and Europe in search of megalithic antiquities, he became aware of other, much older forms lurking in the surrounding landscapes. You can see them, magically appearing in this wonderful collection of photographs. Sometimes they are obvious and you notice them immediately. Then, as you gaze further, other images come into focus – gods, demons, tortured souls, creatures of mythology and potential life-

forms of the future. They are diverse and fluctuating, but in every landscape they are somehow unified, as if they were products of the same dream.

Who then is the dreamer? The imaginative person who sees them, of course. That is the sensible answer, but it is not quite the final one. We are certainly inclined to perceive patterns and symbols in nature. But, equally, nature has a tendency to manifest such patterns, the same ones, repeatedly. The face pattern, for example; it occurs throughout all creation, printed on crysalids and butterfly wings, on the cobra's hood and on the backs of spiders. It is a universal symbol and its meaning is plain to all... Danger! Keep away! There are faces throughout this book, in rocks, clouds, old timbers and the interplay of light and shadow. Most substantial among them are those giant rock-heads on the summits of moorland tors. Naturally today, and in their old legends, they are called the Guardians.

You can look quickly through this book, admiring the author's vision and the quality of his photographs. Then, as you look again, certain images hold your attention and draw you into the dream. These pictures are gateways to a forgotten world, the primordial reality. This is how we used to see nature, as a living creature, animated by spirits. Our modern eyes have lost that perception, but it lingers among artists and mystics and it is at the root of all traditional and esoteric sciences. Codes of geomancy emphasize the importance of observing the forms and images that dominate the local landscape and indicate its character. We call that superstition, and we used to laugh at it, pitying the simple people who upheld it. But that superior attitude is no longer so tenable. Faced with pollution and the current devastation of the Earth's surface, can we afford to maintain the modern prejudice against the spiritual view of nature?

That question, or something like it, is implicitly raised in this book. As his pictures show, Jürgen Krönig is a subtle and sensitive artist, but he is also, first and foremost, a political journalist. This is not 'art for art's sake', but art with purpose and in the service of an ideal. It is a visual Reformation. Here, artfully displayed, are the delights of 'primordial vision'. If you are tempted towards that way of seeing the world, you are invited to look further, and that could revolutionize your life.

John Michell 2001

Introduction

This book's aim is modest. Its intention is simply to reveal the extraordinary variety of artforms in nature. It was John Michell, the writer and philosopher, who inspired me and opened my eyes to the images created by forces like the wind, water, erosion and other geological processes.

This book documents my very personal journey. My fascination for faces and figures in landscapes, rocks and trees, grew out of two of my favourite pastimes. I have always loved to be out in nature despite the fact that I have lived most of my life in big cities. Whenever I had the chance, I took a walk in the countryside. But it was my move to Britain which opened new doors of perception and had an enormous impact on my life. I have been living in England since 1984. Of course I enjoyed London, a vibrant metropolis with much to offer – culture, music and politics; after all, I am a political writer. London was challenging and stimulating. But the longer I lived there, the greater was my urge to escape from the city. I felt a need to get away from the noise, the cars, the pollution and the huge number of people. I began to understand what had inspired an author like Thomas Hardy to write a novel with the title *Far from the Madding Crowd*.

The lure of rural Britain, especially its wilder, untamed areas, proved to be irresistible, especially the open downlands of Wiltshire's prehistoric landscape with its numerous monuments from Bronze age and neolithic times, the rolling hills and cliffs of Dorset, the majestic silence of Dartmoor, Bodmin Moor and Exmoor. I became aware of the ongoing, indeed growing fascination of people with prehistoric sites, when the bitter conflict around Stonehenge erupted in 1985, a conflict about the right to gather at Stonehenge at Summer Solstice and celebrate the rhythm of nature with a free festival. From then on, I was in the grip of megalithomania. I started visiting ancient sites all around the British Isles, from Cornwall to the Outer Hebrides; I climbed up numerous hillforts, searched for inaccessible menhirs and stone circles, photographed remote landscapes, mountains and monuments. The legacy of the megalithic period is still present in abundance all over the British Isles. One of the beauties of a mild obsession (at least I like to think it is mild) with the remnants of our past, is that it leads invariably into the most beautiful, remote areas, quite often the last wild refuges in our densely populated and industrialized countries.

From there the journey led to countries in Europe and around the world, always searching for the remnants of ancient civilizations. Standing stones, stone circles, burial mounds and other stone structures are absolutely everywhere: in Northwest Europe, around the Mediterranean Sea, on all continents. During my travels, on which my wife Katharina has been a wonderful companion, I stumbled across more and more of these mysterious images, for which John Michell has coined the term 'simulacra' in his seminal book of the same name. Once my eye had learned how to

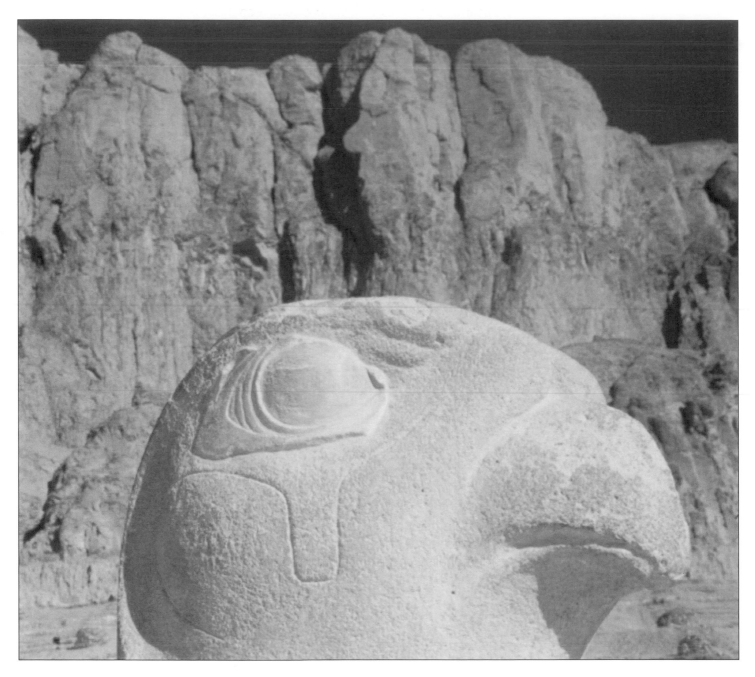

Above the statue of Horus.
Temple of Hatshepsut, West bank, near Luxor, Egypt.

perceive these simulacra, I became aware of the astounding variety of faces and figures in the natural world. Nature has the uncanny habit of creating images which remind us of ourselves: rock formations look like statues from Easter Island, trees grow into clearly recognisable faces or resemble creatures which remind us of mythological figures we ourselves have created in folklore and legends. It might very well be that some of the rocks which look like gods, giants, dragons or demons, might in fact be the source of our mythologies.

There are unmistakeable signs that the awareness of simulacra is growing. After all, no one is ever alone on journeys of discovery. There are always other people on a similar trip; the simulacra section in every issue of the *Fortean Times* magazine is evidence of this. Recently a number of natural images have been published in the mainstream press. British tabloids like *The Sun* and *The Mirror* presented their readers with newly discovered 'faces' on Mars and strangely shaped tree trunks. The colour supplements of broadsheets like *The Times* and *The Guardian* came up with a double-page advertisement (for Californian Wine) featuring the work of the American artist Teresa Shea, who used driftwood at Middle Beach, Point Lobos, in California, to create out of natural sculptures, a new form of landart.

One explanation for the increased awareness of simulacra may be the widespread growing ecological consciousness. People realize that wild, untamed landscapes, quite often exactly the places to encounter simulacra, are ever more endangered by the relentless forward march of human civilization with its tendency to spoil and destroy more and more of the natural world. Journeys to remote places have increased dramatically in the last two decades. Rupert Sheldrake interprets these journeys as modern pilgrimages, driven by the often subconscious wish to feel and see places that our ancestors regarded as special and sacred. These are journeys to an archaic region of our collective imagination. And, of course, there is always the feeling that they might not be there for much longer. The interconnectedness of humanity and our planet – Gaia, as James Lovelock has called this living, self-regulating super-organism – is a truth which more of us are beginning to grasp, even if we don't know how to stop the relentless pace of civilization. William Cobbett, the English writer and radical traditionalist, chose to call this the *Thing*. We are all part of it, enjoying its comfort, mobility and wealth, while worrying about its darker side. After all, modern industrial civilization is based on the principle of eternal progress and infinite growth in a clearly finite world with shrinking resources, rising populations and ever more damage to Nature.

Something else might also contribute to this growing ability to discover and appreciate simulacra. Psychedelic drugs can open those 'doors of perception' which Aldous Huxley wrote about in the last century. Altered or heightened states of mind seem to enable modern people to reconnect with and recognize anthropomorphic images or mythological creatures. Terence Mckenna, who spent thirty years studying shamanism in the

Amazon basin, talked about an 'archaic revival' triggered by psilocybin, the hallucinogenic ingredients of mushrooms, which grow all over the world and have been used over thousands of years by tribal societies to switch on other channels of consciousness, leading to spiritual and religious experiences. One common feature of all these attempts to gain access to a different level of perception seems to be not only mystical experiences and the encounter with archetypal images, but at the same time nature is experienced as being alive. Whatever one's personal attitude to the psychedelic revolution of the last forty years, it is a fact that the use of psychedelic drugs such as cannabis, magic mushrooms and LSD, has influenced and shaped the perception of a few generations now, despite a relentless war against the softer drugs. These days even contenders for the leadership of Britain's Conservative Party are contemplating the legalisation of cannabis. Hopefully, however, the simulacra presented in this book will be recognised and appreciated in whatever state of mind the reader may be in.

In some cases, I took a photo of a landscape or monument and only discovered the simulacrum afterwards by looking at the print or slide. When I took the picture of Horus in front of the Egyptian temple of Hatshepsut, I was not aware of the striking profile in the walls of the rocks which the builders of the temple had chosen as a dramatic background for the monument. In most cases, though, I recognised the images and photographed them deliberately. I was not quite sure whether I should offer my personal interpretation of the images or whether it was best left to the reader to make up their own mind. After all, the image is in the eye of the beholder and as we all have different ways of seeing, we can all come up with different interpretations. In the end I decided to give my view and would like to invite the reader to join me on this adventure into the wonders of nature. Hopefully my photographic journey will please or, even better, excite the reader. It may be the beginning of their own journey of discovery.

Simulacra – Some thoughts about Nature's Artwork

The photographs show features which, in many cases and without too much strain on the imagination, resemble human faces and features. Some of the images might even suggest another dimension, a reality connected with our dreams, perhaps nightmares, or with the memory of an archetypal past where our legends and myths come from – a world inhabited by mythological figures such as giants, gods, trolls and other strange creatures. Two questions spring to mind immediately. Why do we see these images? Why do they exist? There is no conclusive answer.

John Michell emphasizes, in his book *Simulacra*: "The human eye that sees its own and other familiar images in the fluctuating forms of nature is merely exercising its normal function, observing, in accordance with the way it was designed, that which nature was correspondently designed to reveal." Another question is why are there so many simulacra? Is it pure chance, in a Darwinian sense, or are there indeed forces at work which our ancestors would have interpreted as gods and spirits? One thing is clear. Nature has a tendency to reproduce again and again the pattern of human features, as if constantly driven to recreate the human form. In the end, a definite explanation is not possible; we can only ponder and speculate about possibilities. There is no need to invoke teleology in attributing to nature the tendency to create these images. All that remains at the end of the day is a beautiful mystery. But we should remember that quantum physics tells us there is an inextricable link between the observer and the observed. We cannot separate the world around us from our way of seeing it.

John Michell recommends moderate use only of the specific function of human consciousness to see images and features in nature, warning with gentle irony of the potential pitfalls and dangers of an all too obsessive pursuit of Nature's artwork. Indeed, people have been driven to near madness by their pursuit of simulacra, or at least their peers regarded them as having gone mad. One example is the fate of Antonin Artaud, a visionary poet, who was declared insane after his journey to a mountainous region in Mexico. He had written: "of course there are places on earth where nature, moved by a kind of intelligent whim, has sculpted human forms."

Perhaps we should not be too worried about our ability to recognize shapes and images created by the forces of nature. Simulacra-searching is great fun, there is much good company to be found on such travels, and the number of connoisseurs of the subject is growing rapidly.

Indian god.
Falls at Jirijirimo, Guiana.

Simulacra – An ancient art

When I started my journey, I did not know that the features created by natural forces had been with us since far back in time. All around the world ancient people recognized faces and figures in rocks and trees and they often revered the places where they found these images. In their mythology they interpreted them as gods, spirits or creatures of the nether world. The numbers of legends connected with strangely shaped stones that resemble human or animal figures, are myriad. Legends are as much part of the landscape as the artefacts themselves. "The Indios of the Americas had some special name for, or some special legend about, every peculiarly shaped rock," wrote the British explorer Richard Schomburgk, in *Travels in British Guiana* in 1922. There, at the Falls of Jirijirimo, a rock resembles the face of an Indian god. According to local legends, he guards the spirits of the dead chieftains which are represented by huge boulders scattered below the waterfall.

Cochise's Head.
Arizona.

There are many rock images like this to be discovered all over the world, too many to give a balanced global overview. Rocks with mythological associations can be found in many countries. The United States boast plenty of fine examples, especially States like Wyoming, Utah and Arizona, where Cochise's Head is a famous landmark in the mountains near a former Apache stronghold. Nathanial Hawthorne wrote a story about the

'Old Stone Face' at Franconia in New Hampshire, discovered in 1805 by a hunter. According to local Indian prophecies, a great tribal leader, looking exactly like the Old Stone Face, will one day save his people. In Tadshik, Russia, there is an elephant sculpture in granite. In the Western world it probably would already have been turned into a major sightseeing attraction.

In the British Isles, Major Hayman Rooke, a pioneer archaeologist, nicknamed the 'Resurrection Major' for his obsessive programme of barrow digging during the eighteenth century, concluded that the rocks and tors of Yorkshire and Dartmoor were the remains of a long forgotten civilization. In 1786, in a paper for the Society of Antiquaries, he attributed the rock statues of Brimham (10 miles Northwest of Harrogate), to 'artists skilled in the power of mathematics'. The enormous logistical and technical effort needed to create and erect these rock sculptures led him to believe that only a civilization with an advanced knowledge could have been responsible. Many researchers shared his disbelief in the natural origins of these monumental relics of a long-gone past they encountered on their journeys of exploration in their own countries or around the world. Many scientifically trained minds believed the bizarre sculptures crowning the moorlands and hills of Britain were the work of the mysterious Druids who were also thought to have built the enigmatic stone circles of Stonehenge and Avebury. Even in the twentieth century we find examples of this attitude about the origins of simulacra. In the 1970s, a Peruvian archaeologist, Daniel Ruzo, discovered a group of huge rock formations depicting strange animals and human heads on a mountain plateau in the Peruvian Andes. He was in no doubt that he had found the remains of a hitherto unknown prehistoric civilization. He called it the 'Masma culture'.

These examples prove that scientists were equally prone to interpret natural formations as remains of an ancient culture as outsiders or eccentrics. Sometimes they were driven by wishful thinking, hoping to present to the world artefacts of unknown civilizations or they just could not accept the idea that nature is able to create such perplexing images. Most disputes of the last few centuries about the origins of rock simulacra have been resolved in favour of natural forces, but there will always be new contentious objects and artefacts to be hotly debated. Lately, giant pyramid-like structures with terraces, ramps and large steps, submerged in the coastal waters of Yonaguni, a Japanese island near Okinawa, became the subject of an intense discussion. Some Japanese archaeologists and geologists are convinced that this 'pyramid' is man-made, a view shared among others by the British author, Graham Hancock. For them these structures constitute hard evidence for a pre-diluvian civilization, especially now that Japanese researchers have presented new evidence: marks on the stones seem to prove that they were hewn. Other researchers still remain convinced that only natural forces like water and wind were the architects. In this specific case, a third explanation could perhaps provide an answer.

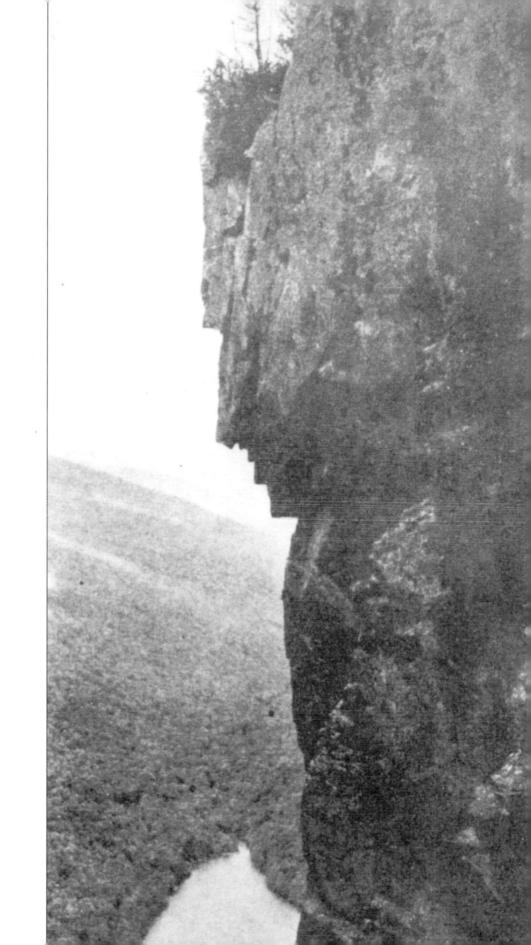

The Old Stone Face.
Franconia, New Hampshire.

The inhabitants of this island might have been fascinated by the remarkable natural features and might have embellished them, turning nature's monument into a place of worship and tribal ceremonies. It would not have been a unique or an unusual reaction at all. In many places all over the world people recognized the mysterious beauty of nature's work and began to enhance and decorate these locations. Around Glastonbury Tor, a conically shaped hill in Somerset, ancient people built a processional path leading to the top of the Tor, a path which spirals around the hill in the shape of a Cretan maze. The Extern Stones in Germany's Teutoburger Wald, an impressive outcrop of basalt pillars in the midst of a forest, have been a sacred place for thousands of years, from Germanic times to the so-called 'New Age' of the late twentieth century. The rocks, looking like large birds of prey or dragons, situated beside a lake, have been used as a shrine and temple to nature for a long period of time.

Some mountains are huge simulacra of pyramids. In many countries they are regarded as sacred. Nepal's holy mountain in the Annapurna region, shaped like a pyramid, is said to be the reason why the greeting 'namaste' (I salute your soul), is accompanied by bringing the outstretched fingers and hands together at the fingertips, thus forming a pyramid shape. The American astronomer Farouk El-Baz, who used to work for Nasa, recently surprised the scientific world with his suggestion that the pyramid-builders of Egypt were inspired by simulacra. He presented pictures of impressive natural rock formations in the Sahara desert which were carved by wind, sand and other natural forces, and looked strikingly similar to the great cultural achievements of the Old Kingdom. Of course this can't be interpreted as clear evidence of the origins of the pyramids, but at least it illustrates the growing awareness of nature's artistic power to inspire us humans.

Simulacra - Folklore and Mythology

There is a striking similarity between the folklore surrounding standing stones and menhirs that have been erected by our neolithic and Bronze Age ancestors, and rock simulacra. Both were quite often interpreted as people or warriors frozen to stone, occasionally awakening, dancing or drinking or, like Bowerman's Nose on Dartmoor, going out on a wild hunt. Bowerman's Nose is an impressive rock sculpture, rising at the edge of Hayne Downe, near Houndtor. The rock statue is said to be a former gentleman with a passion for the hunt who comes alive one night of the year, chasing souls across the moorland, accompanied by a pack of ferocious dogs. Sir Francis Drake, a military leader with occult leanings, reportedly had a vision of this frightening wild hunt whose dogs can be seen on Houndtor frozen in stone.

 To this day the legends of local people tell us that giants were the artists who erected granite statues like Bowerman's Nose. Science presents another explanation for these remarkable sculptures. They are the result of a unique geological process which took place eighty million years ago, when molten lava was forced out of the interior of the earth, creating the monumental artwork topping the tors of Dartmoor, Bodmin Moor and similar places around the world. The lava cooled, then the forces of evolution went to work over millions of years. The creation stories in folklore, however, have one advantage over science. They encapsulate the spirit and mystery of these monumental sculptures and speaks to us of the 'folksoul' of our ancestors which we have inherited.

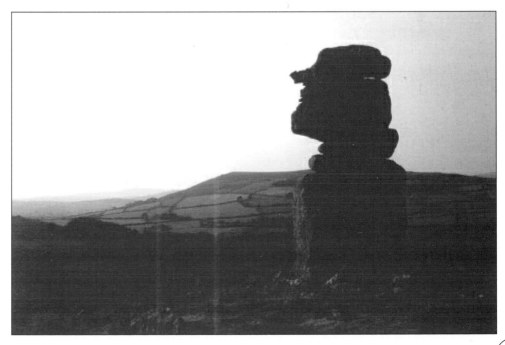

Bowerman's Nose.
At the edge of Hayne Downe,
Dartmoor, Devon.

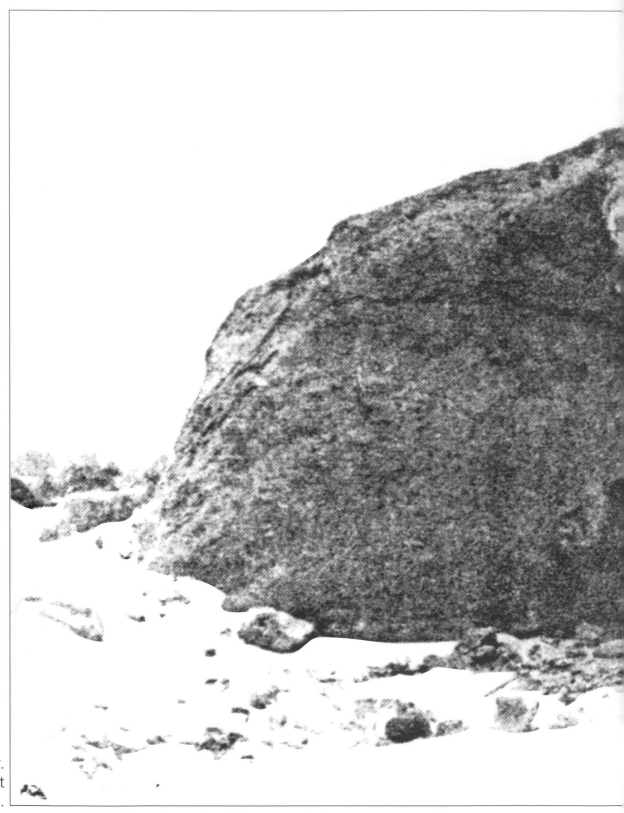

Granite elephant.
Tadzhik, formerly part
of USSR.

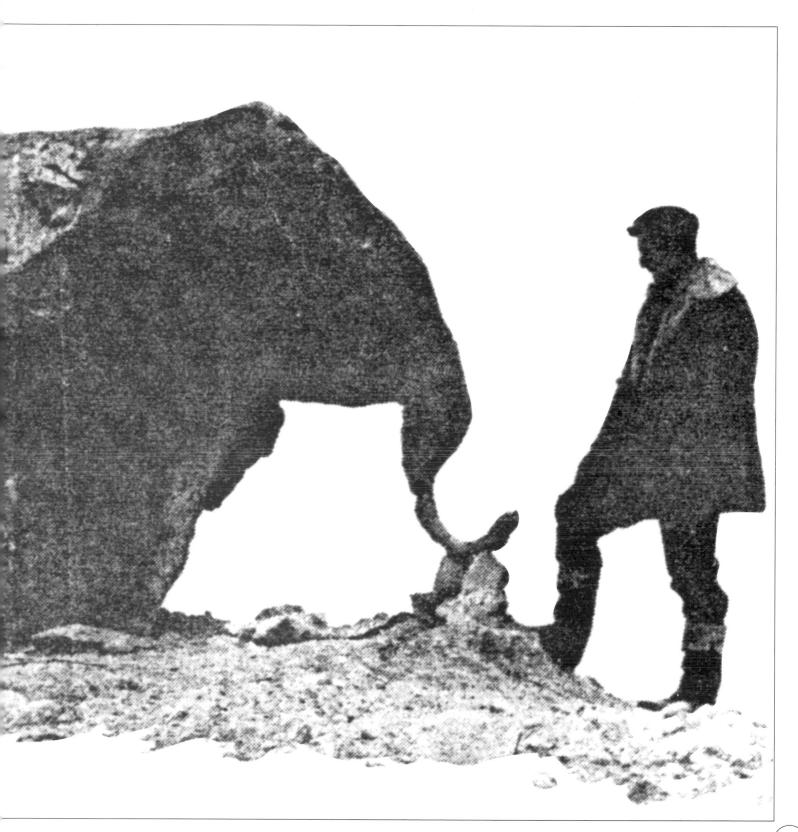

Sigiria 1 and Sigiria 2 (opposite) by Fabius von Gugel.
Jungle of Sri Lanka.

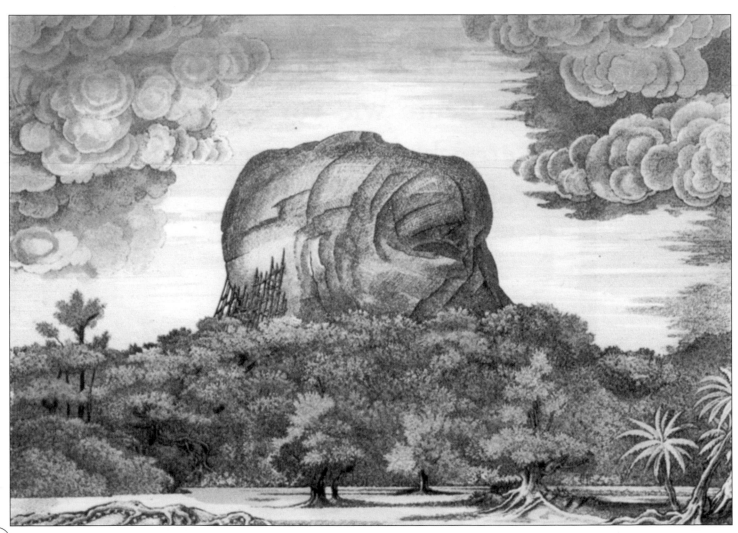

Simulacra and Art

Some members of the fraternity of the visual arts do not enjoy simulacra. A friend of mine, a sculptor, reacted with obvious irritation when I showed him some pictures. He seemed to feel that rock formations looking like statues, faces or animals, would devalue the artistic efforts of humans. He thought it inappropriate to see something as art that was, in a Darwinian sense, created by blind chance or pure coincidence. Maybe there was something else – a feeling that human art, even in its most noble endeavours, is always an attempt to translate aspects of the natural world into the language of visual art? Yet simulacra evolve right at the source itself. Some artists seem to have seen it that way. They were drawn to the artwork of nature and to the power and beauty of the living landscape. Visual artists and novelists in particular, were gripped by the mythical and

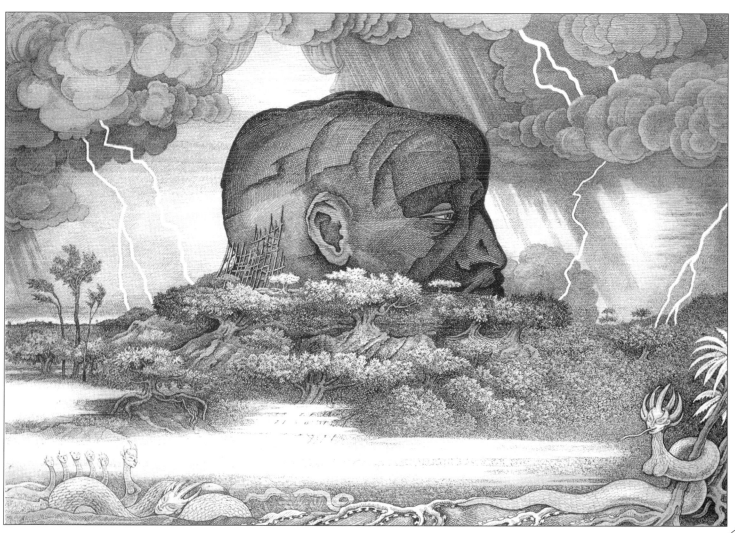

poetic qualities of these features. They are reflected in the artistic visions of William Blake or in Caspar David Friedrich's landscapes. Henry Moore's work would not have been possible without the rock formations and the prehistoric monuments of Yorkshire and other parts of Britain, as he himself admitted freely. In the early decades of the last century, Fabius von Gugel, an Austrian painter in the fantastic and surreal tradition, encountered in the heart of the jungle of Sri Lanka, a mountain shaped like a cube. Sigiria, the name of this remarkable place, was the fortified castle of a kingdom from the fifth century AD. One night, during a heavy thunderstorm with lightning, the artist 'recognized', in a flash of inspiration, the forces of change which turned the inanimate world into living forms. The mountain became alive, turned into a mythological head, roots and trees changed into spirits and strange creatures. The animistic vision of the artist reveals that there is no such thing as inanimate nature. The world around us is alive and humanity is part of a larger living whole.

The ancestor.
Avebury Circle, Wiltshire.

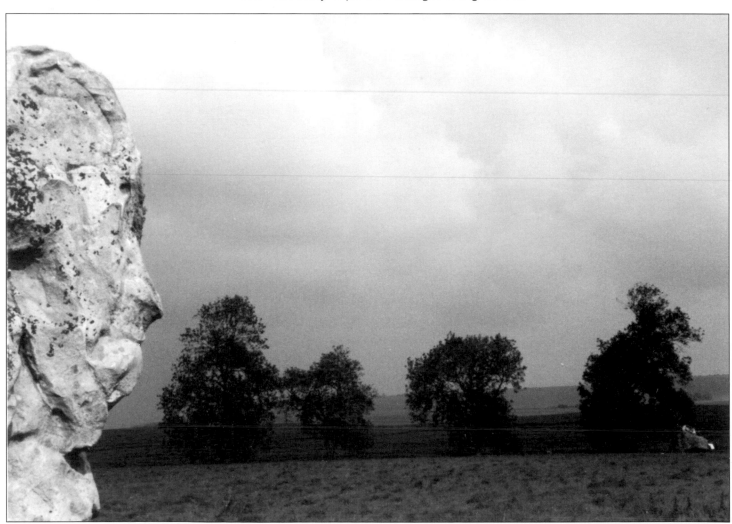

Genius Loci – Spirit of Place

One aspect of simulacra which has fascinated artists, writers and philosophers from antiquity to the present day, not least the Neo-Romantics like Paul Nash, is the concept of a *genius loci*, a local spirit which, in the words of John Michell, "influences the nature and appearance of everything in its domain." Roman thinkers like Vitruvius and Proclus believed that people and animals reflected in their outer appearance the country or region they lived in, "marked and coloured to resemble their environment." C G Jung was convinced that a *spiritus loci* existed which is "indescribably present as a sort of atmosphere that permeates everything, the look of people, their speech, clothing, smell, their interests, ideas, politics, philosophy, art and even their religion." Ernst Jünger, a German writer and philosopher, had similar thoughts. He was struck by the correspondence between landscapes, their artefacts, and living creatures. In *Subtile Jagden* (*Subtle Searches*), Jünger ponders on the existence of some 'scripture' in nature, which the eye that is experienced in the scrutiny of the subtlest writings, "will recognise the characters of a continent, an island, an alpine range just as experienced people know how to tell a person's character from his handwriting." The correspondence of landscape, living beings and natural artefacts is a fascinating subject which deserves more study, though I doubt whether this link could be proved in any scientific way. It can be understood and felt intuitively, as poets and visionaries do. It remains their privilege to express this deeper understanding. As Ernst Jünger said: "The power of territories coming out of great depths does not only determine the harmony of living creatures with one another but also with the inanimate world".

The concept of an intuitive understanding of special places and their local spirit has been tossed aside by modern psychology and architecture, as too much of modern building testifies. Often they are exactly what Le Corbusier said about the buildings he and his followers tried to achieve, 'machines for living in', built in the spirit of mechanistic science which radically broke with the traditions of the past. But the importance of the differing quality and spirit of a place was never lost completely, even in the western world. It is alive in many rural regions, outside the big city landscapes and metropolitan snobbery. Yet despite the dominance of a modern, reductionist and materialistic world view, many people feel inspired at special locations. Instinctively they feel that not all places are the same and they try to rediscover the forgotten heritage of intuitive understanding. Some of these places have a certain atmosphere, a numinous quality we can feel at ancient and sacred sites like Stonehenge, near a single menhir in the middle of a remote moorland, in ancient woodlands or in the shadow of granite pillars in mountains, an insight reflected in many paintings by Turner, Constable and Caspar David Friedrich. In his *Studies in American*

Literature, D H Lawrence expressed this feeling beautifully: "Different places on the face of the earth have different vital effluence, different vibrations, different chemical exhalations, phasity with different stars: call it what you like, but the spirit of place is a great reality." In the book *Power of the Place*, James A Swan, Professor of Anthropology at California University, interprets D H Lawrence's statement as an implication that some places may have extraordinary inspirational qualities. One example of the inspirational power of a location is the story of how Tolkien, in a meditative state on the earthbank of Avebury, was sparked with the literary vision which gave us the book *The Lord of the Rings*. Is it pure coincidence that there seems to be a troll emerging from the intertwined and knotted roots of the beech trees at Avebury?

But it is not only the artist or poet who possesses a sense of the spirit of place. Many of my friends who meet up for walks through the English countryside are drawn to certain places and monuments. They too seem to feel at these locations a subtle but unmistakeable mood. There is a rich tradition of special places. Even Chistianity's way of building churches, chapels and monasteries on old pagan sites could be understood as an acceptance of the continuity of a tradition at places which are always described in terms of spiritual and sacred values. A purely rational approach will fail to understand the idea of *genius loci*. Goethe, one of our great masters of words, confessed to the limits of the written or spoken word. A person able to decipher the meaning of nature around him would soon be able to dispense with them: "By contrast, how the gravity of Nature and her silence startle you, undistracted, before a barren ridge or in the desolation of the ancient hills." Human experience has always been a balance between the known and the unknown, between this world and the 'otherworld'. As long as we think we can capture this side of nature in scientific formula, we will not understand it.

Simulacra and Time

Simulacra represent a link between human consciousness and the surrounding world. They can have an effect on our perception of the world we live in; they could function as a gateway to the dimension of time. Rock faces and figures are geological metaphors. They help us to comprehend the concept of 'deep time', as Stephen Jay Gould calls it. Deep time is an attempt to explain the limit of humanity's imagination about the vast cycles of time which we are not able to grasp. An abstract intellectual understanding of what deep time stands for, comes easily enough, writes Gould, "getting it into the gut is quite another matter." Simulacra in granite and rocks have been created through geological events; most of the time this is a slow and steady operation of ordinary causes that would, when extended through the long cycle of deep time, manifest themselves as dramatic, sometimes catastrophic events – magma, molten rock breaking free from the interior of the earth, bursting through the surface, then cooling and getting shaped by weather, water and erosion. The vast time-span in which rocks evolved and were shaped into images and faces, are a reminder of what Stephen Jay Gould calls, "the great temporal limitation imposed by geology upon human importance." At the same time, the history of nature and of humanity cannot be separated as they are inextricably linked. Both have been shaped by cataclysms, dramatic and often catastrophic changes, which led to dark ages and the loss of knowledge and understanding. Prehistoric monuments like standing stones erected by man, are a reminder of that too. They are silent witnesses to a civilization we know very little about. Faces or statues of ancient rock, carved by evolutionary forces, are stretching back much deeper in time.

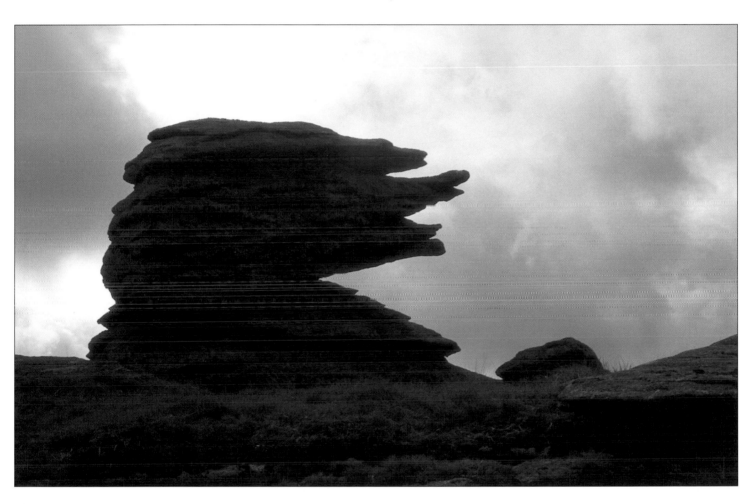

A dark stormy day.
Dartmoor, Devon.

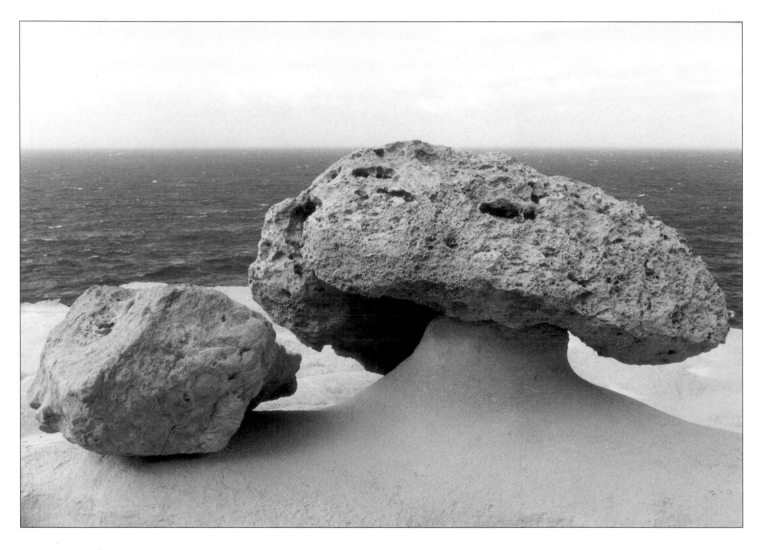

Fungus rock.
Western coast of Gozo, near Malta.

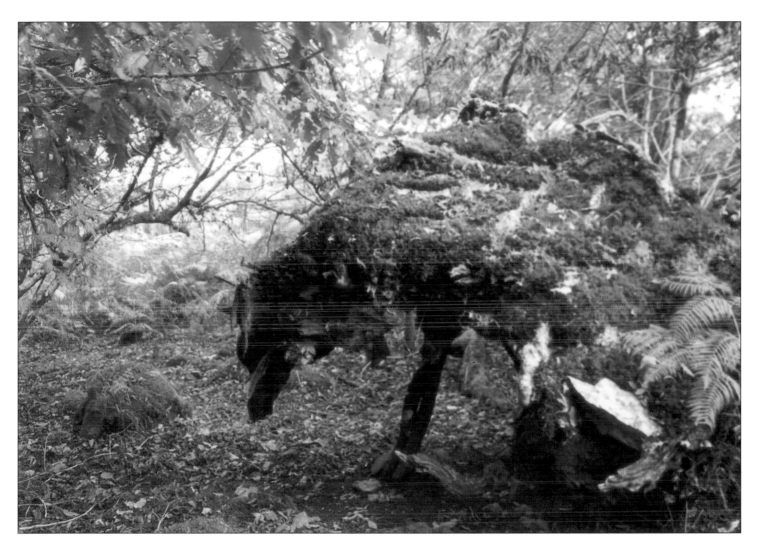

Fox.
Tycanol wood, near Meibion Carnedd, Preseli Hills, Pembrokeshire, Wales.

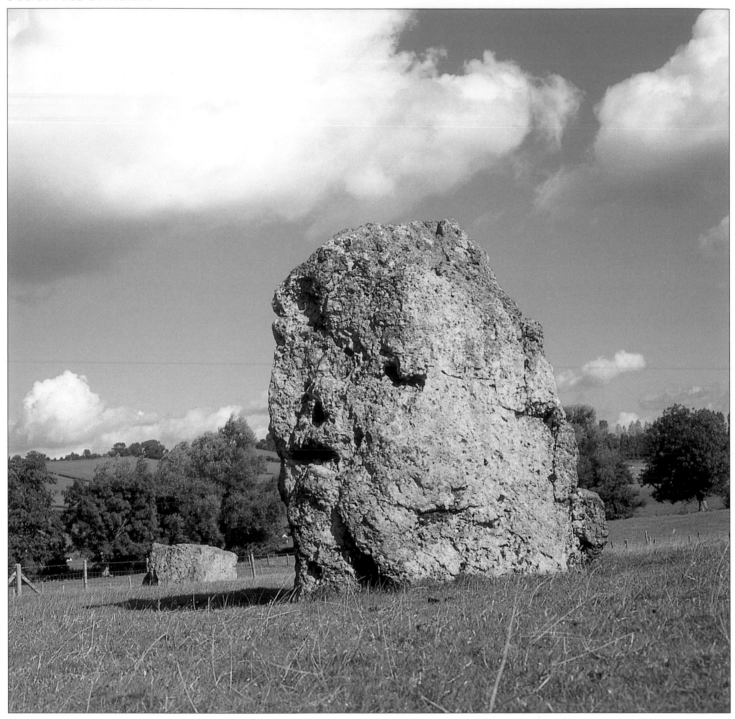

Part of a wedding party turned to stone by the devil, according to local legend.
Stanton Drew stone circles, Avon.

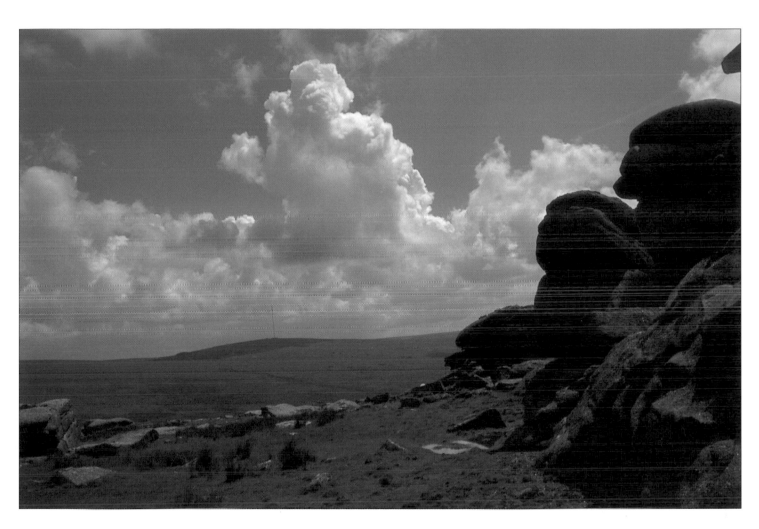

Autumn on Dartmoor.
Devon.

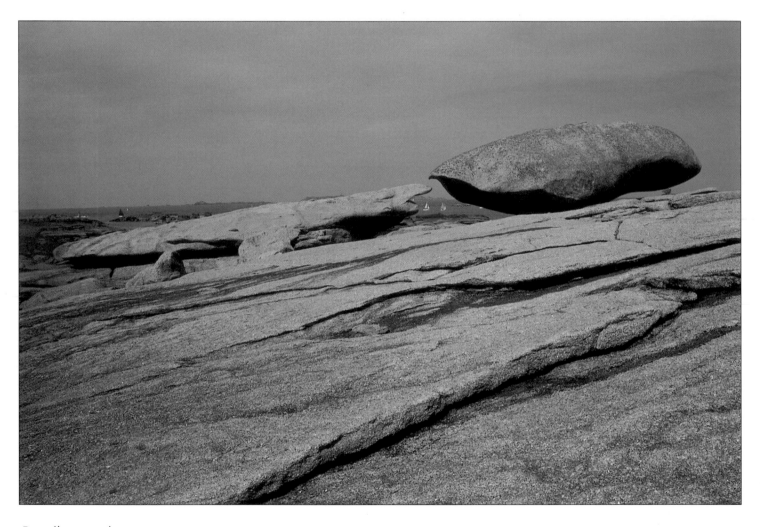

Reptiles on the move.
Northeastern Britanny coast, France.

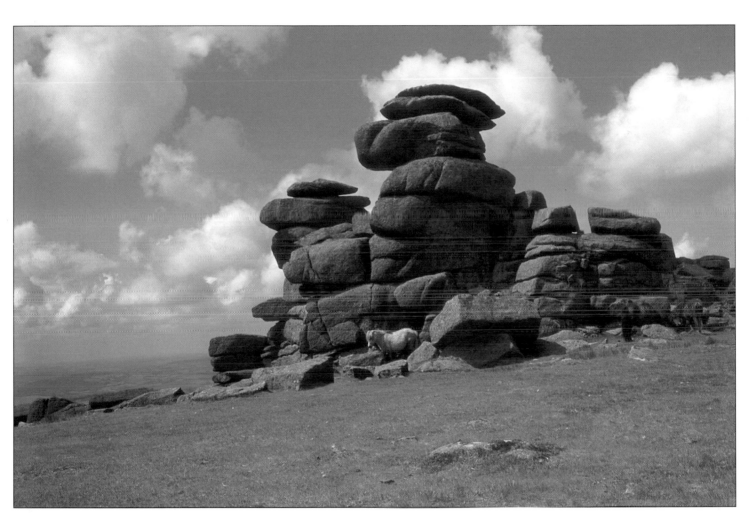

Friendly giants.
Great Staple Tor, Dartmoor, Devon.

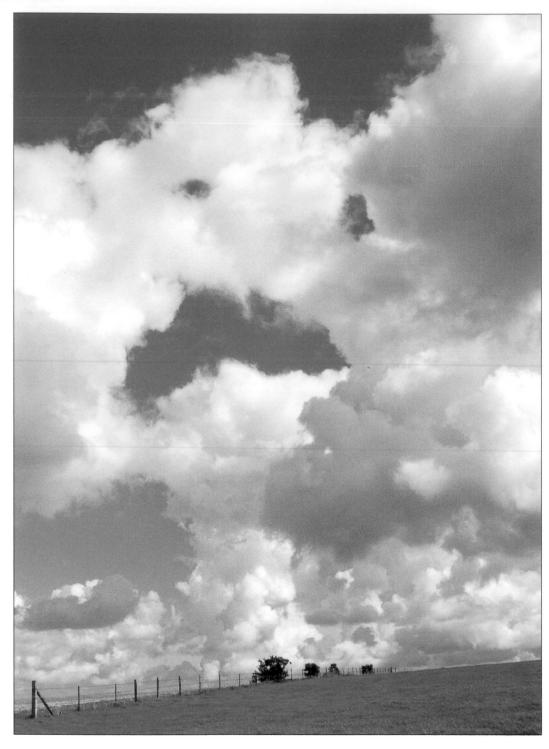

Cloud conversation.
Above the hills of Southern Wiltshire.

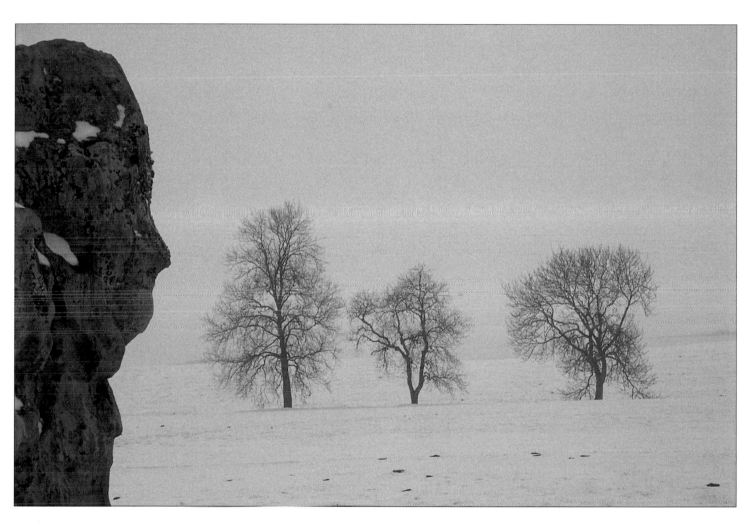

The ancestor.
Avebury Circle, Wiltshire.

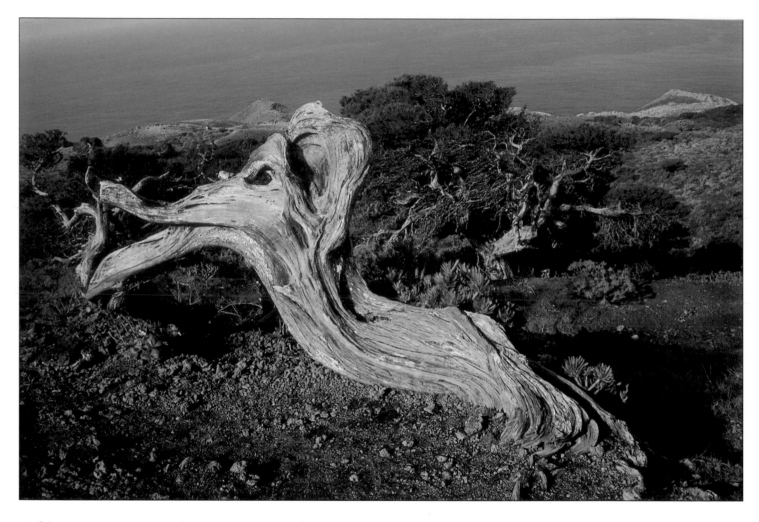

Sabina tree, over one thousand years-old.
El Hierro, Canary Islands.

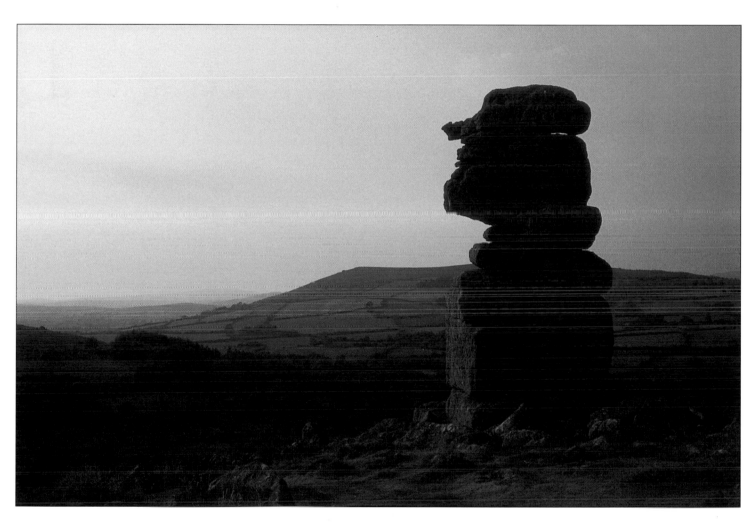

Bowerman's Nose.
At the edge of Hayne Downe, Dartmoor, Devon.

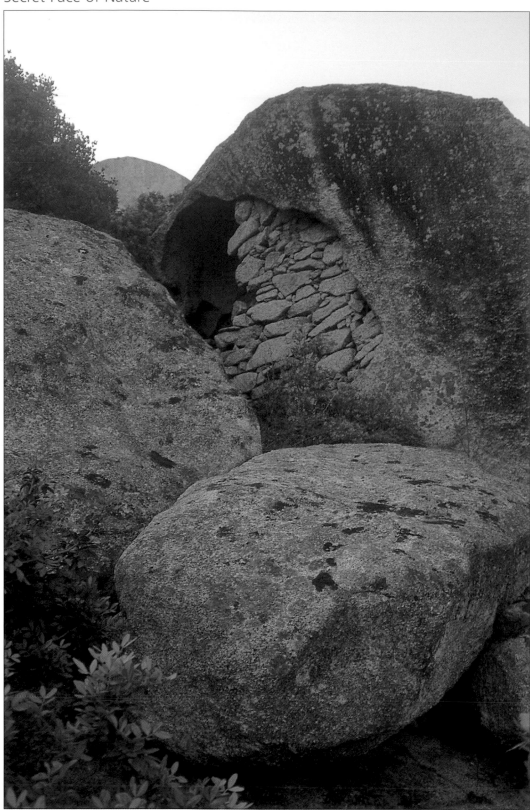

Under the hood.
Mountains of Sardinia.

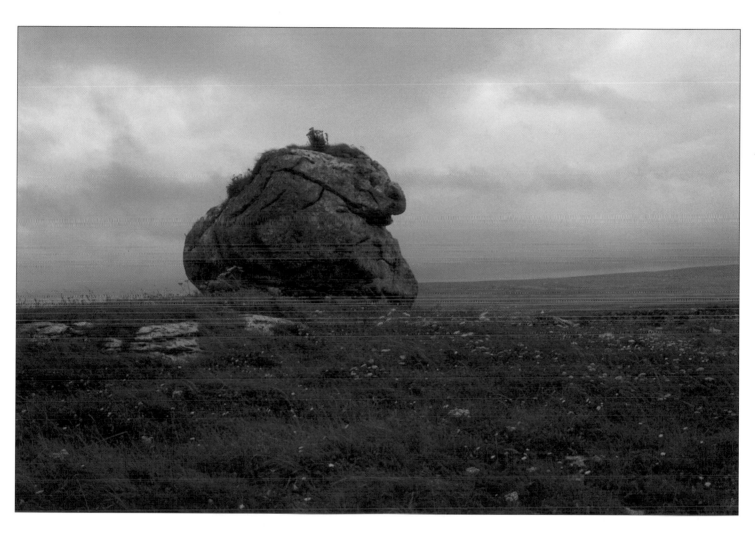

The chicken.
On the coast at the Burren, Ireland.

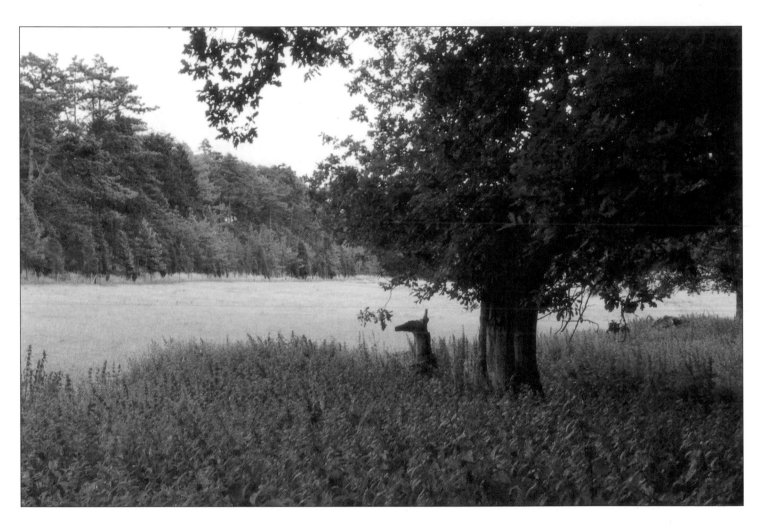

Deer.
Chute Causeway, near the border between Wiltshire, Hampshire and Berkshire.

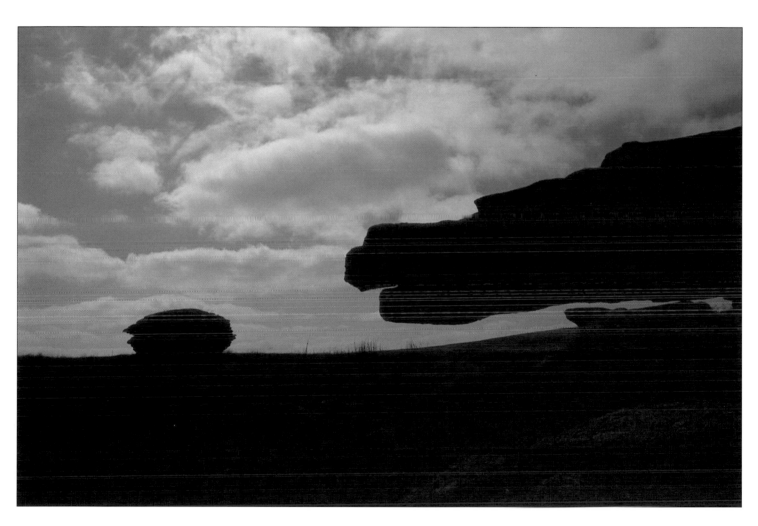

Crocodile.
Near Watern Tor, Dartmoor, Devon.

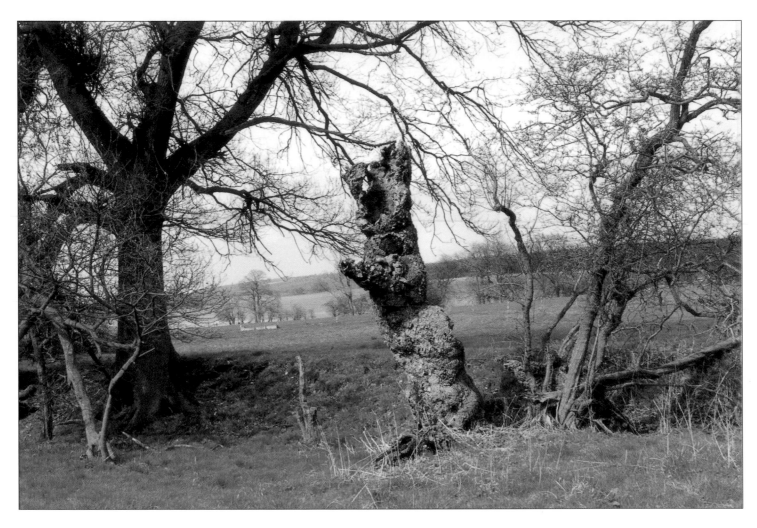

Giant squirrel.
Near Westwood, Wiltshire.

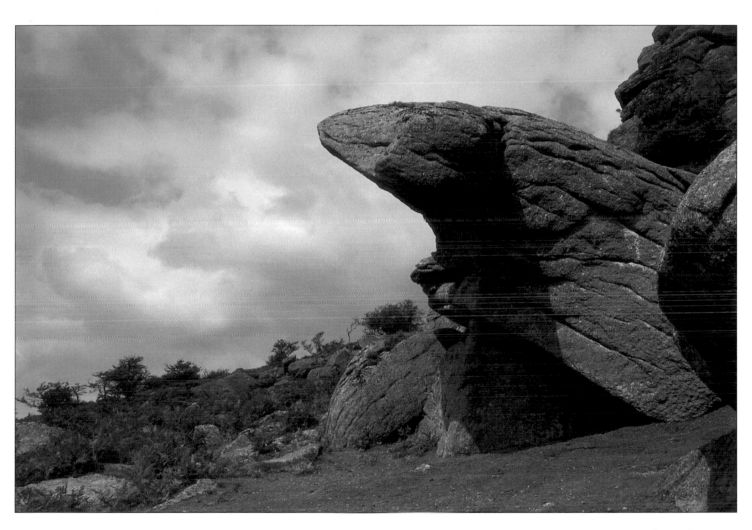

Jumping rat.
Vixen Tor, Dartmoor, Devon.

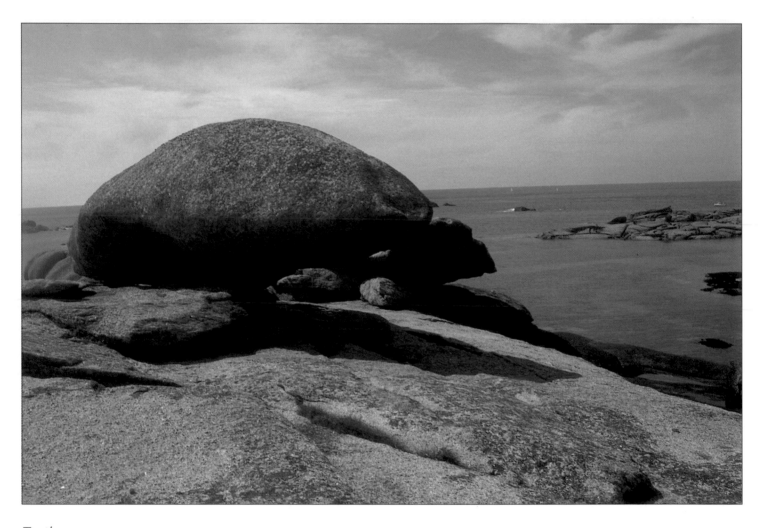

Turtle.
East coast of Britanny, France.

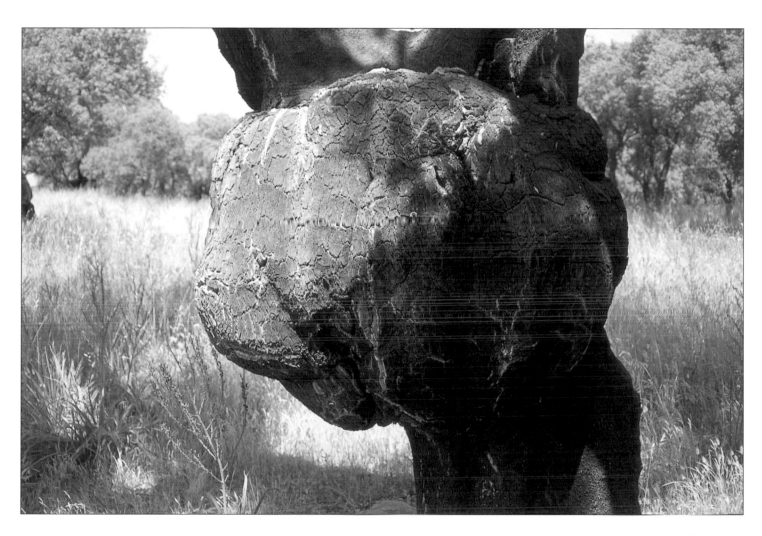

Heffalump.
Cork oak on Sardinia.

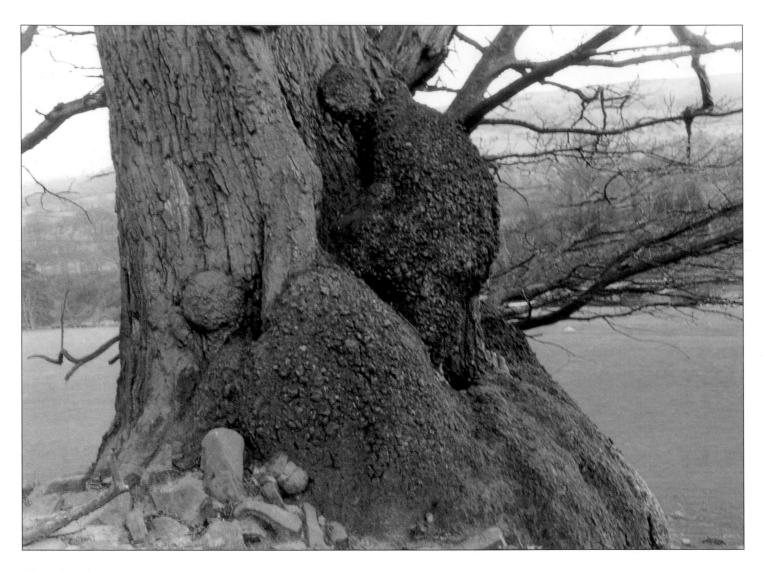

Sleeping bear.
Usk Valley, Brecon Beacons, Wales.

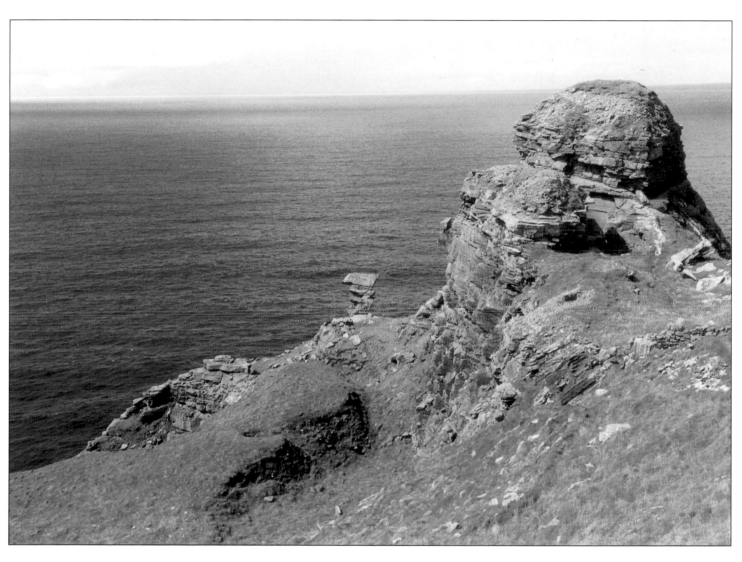

A distant view.
Near the Cliffs of Moher, West coast of Ireland.

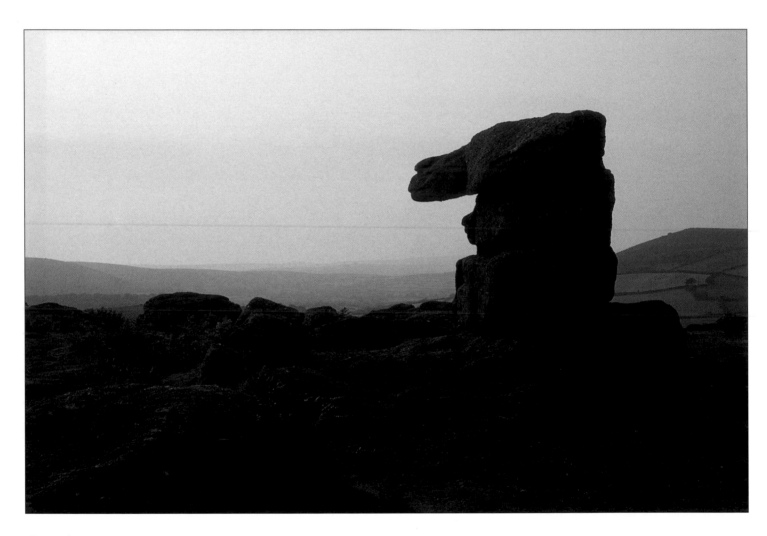

Serenity.
Hayne Downs, Dartmoor, Devon.

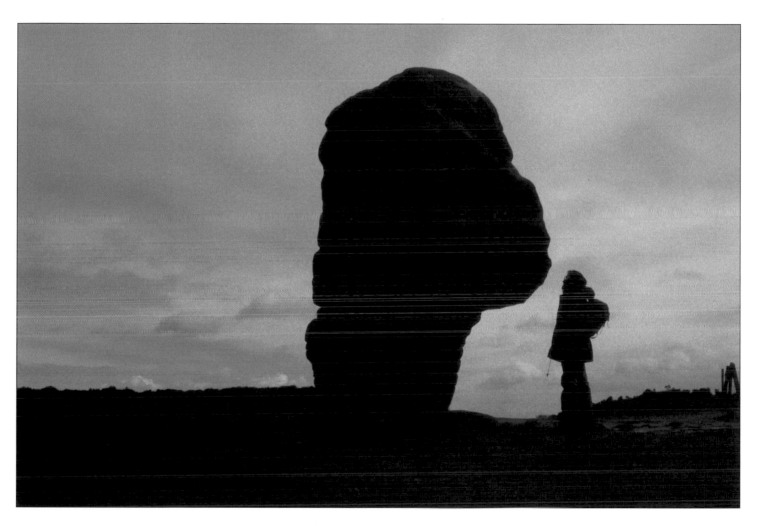

Mythology meets humanity.
Peak District, Derbyshire.

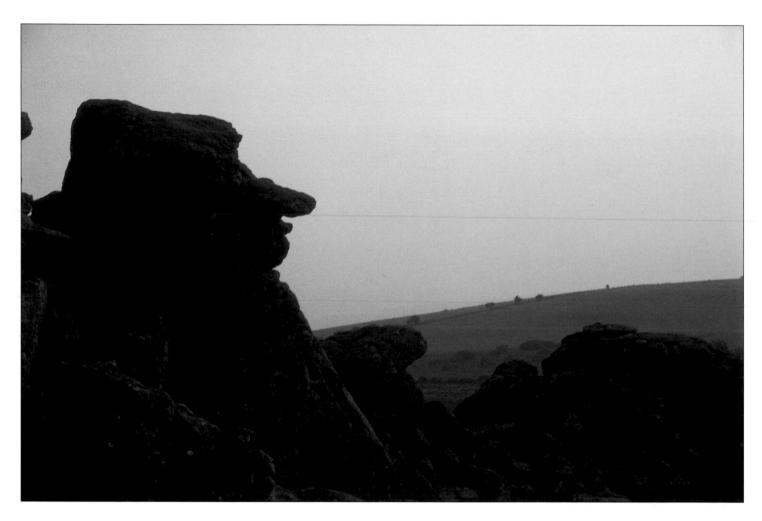

Curmudgeon.
Hound Tor, Dartmoor, Devon.

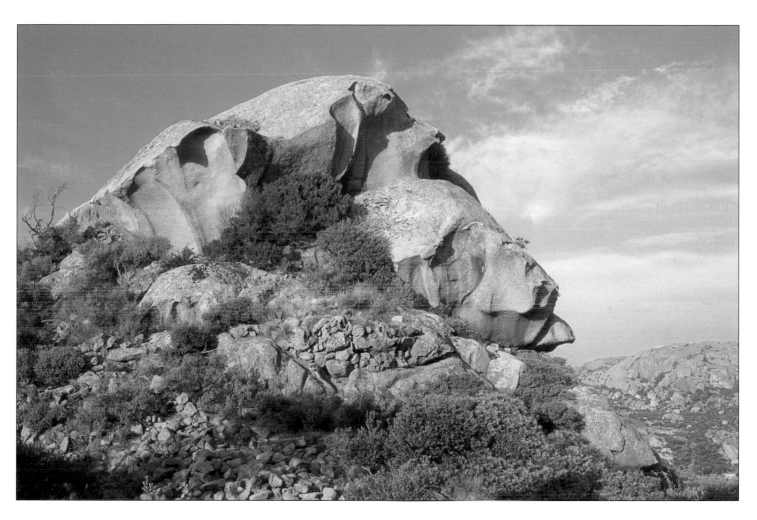

Sardinian ape.
Near Arzachena, Sardinia.

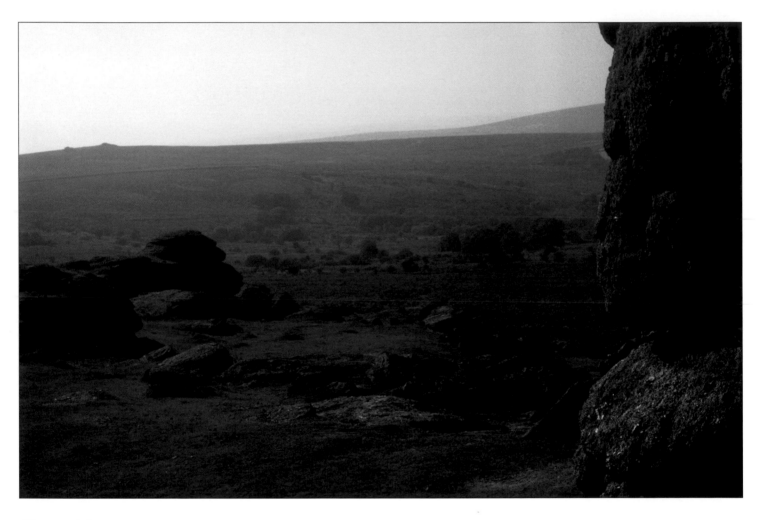

The watcher.
Cox Tor, Dartmoor, Devon.

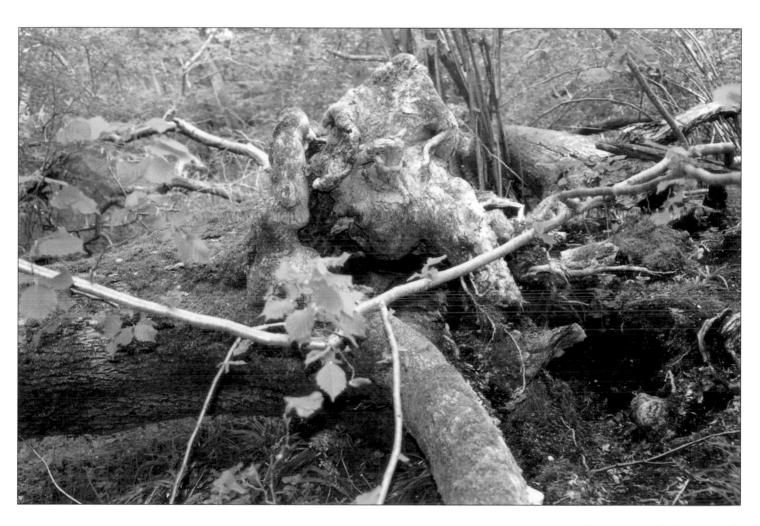

Creatures of the wood.
Haygrove Wood, Wiltshire.

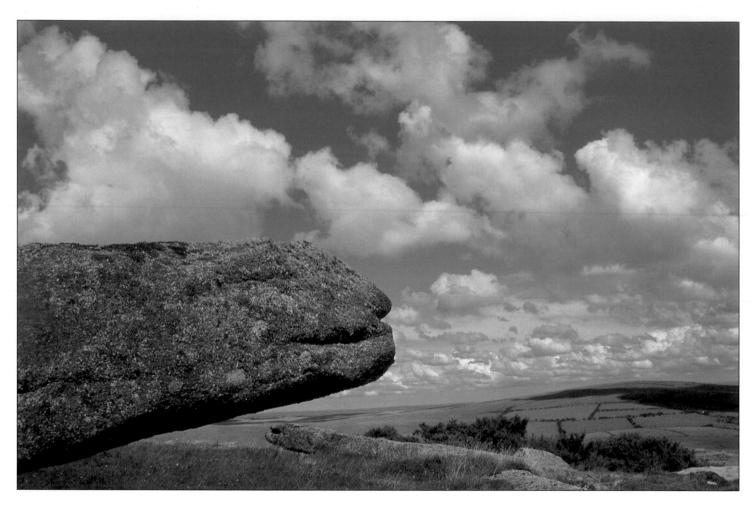

Saurian smile.
Bodmin Moor, Cornwall.

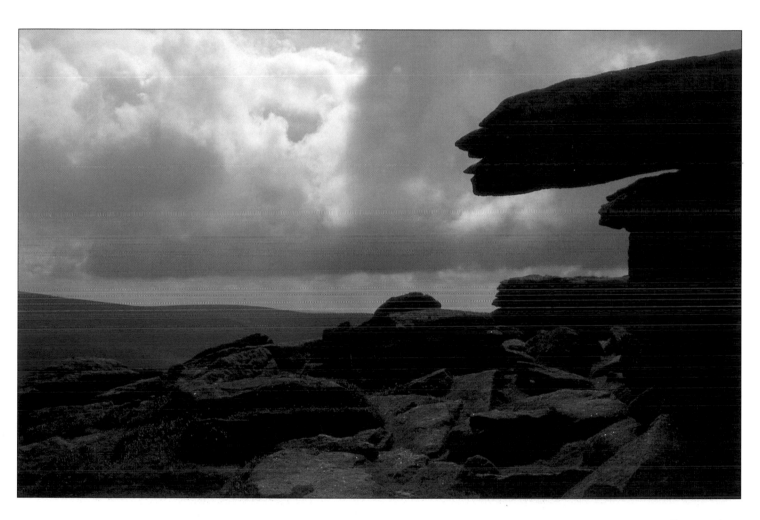

Gargoyles.
Belstone Tor, Dartmoor, Devon.

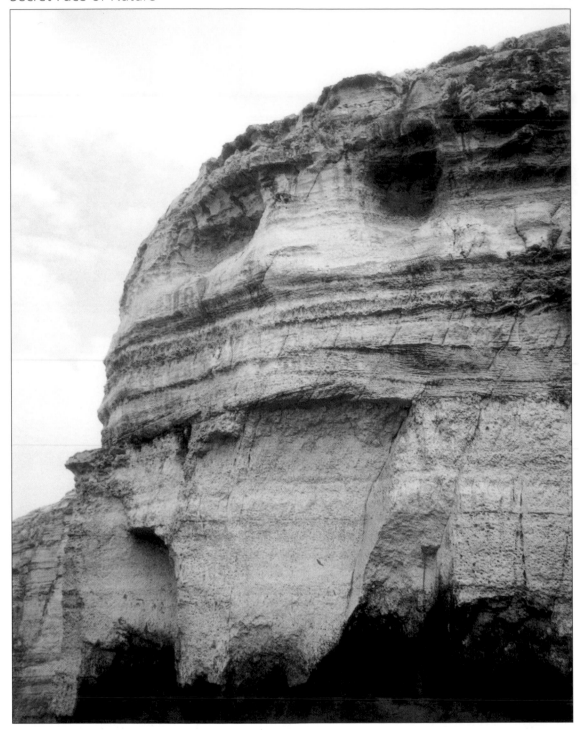

Pagan god.
Cliff at Gozo, near Malta. Folklore interprets the features in the cliff as the face
of a god. Local fishermen offer boat rides to view it from the sea.

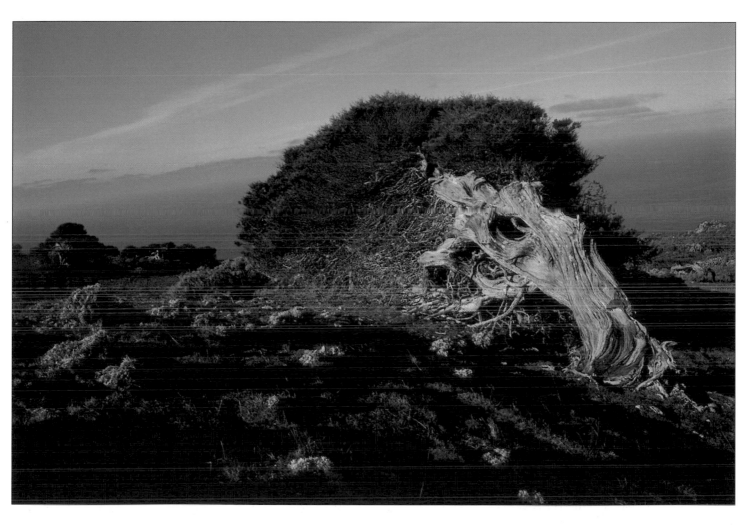

Alas, poor Yorrick!
A Sabina tree, Western El Hierro, Canary Islands.

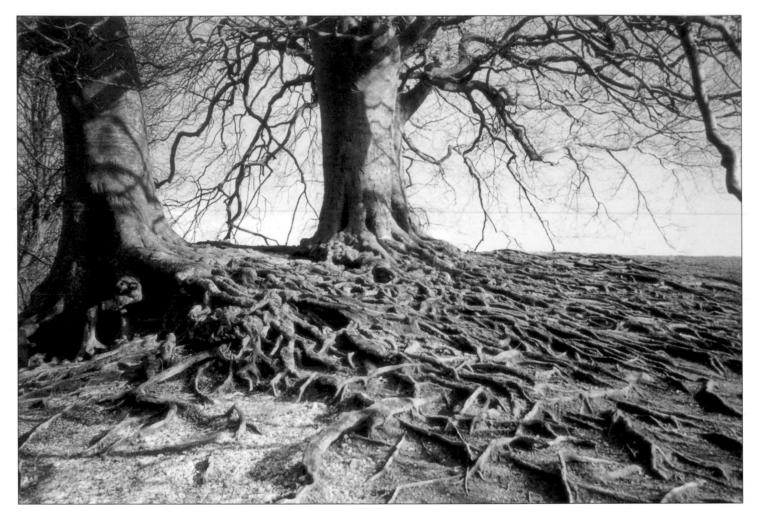

Troll emerging from the roots of the Tolkien tree.
Part of a clump of beech trees on the bank at Avebury, Wiltshire. Their twisted interwoven
roots form patterns said to have inspired Tolkien to write *The Lord of the Rings*.
Tolkien reportedly sat here, deep in contemplation.

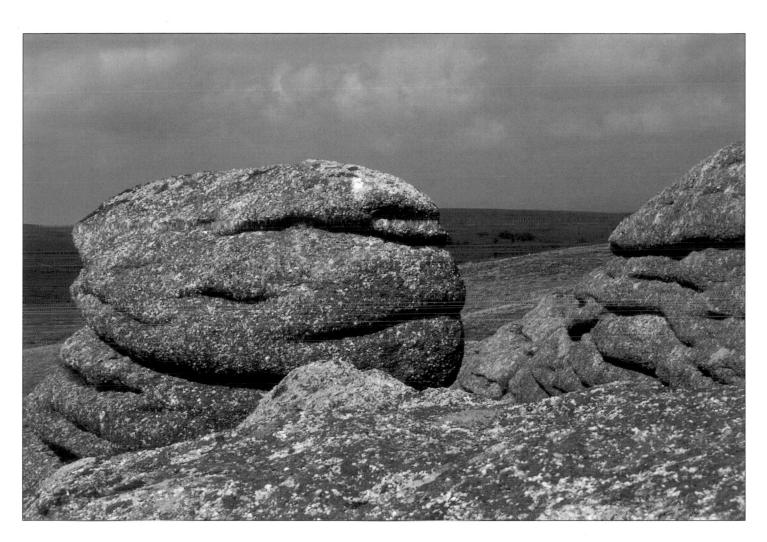

A grumpy day.
Oke Tor, Dartmoor, Devon.

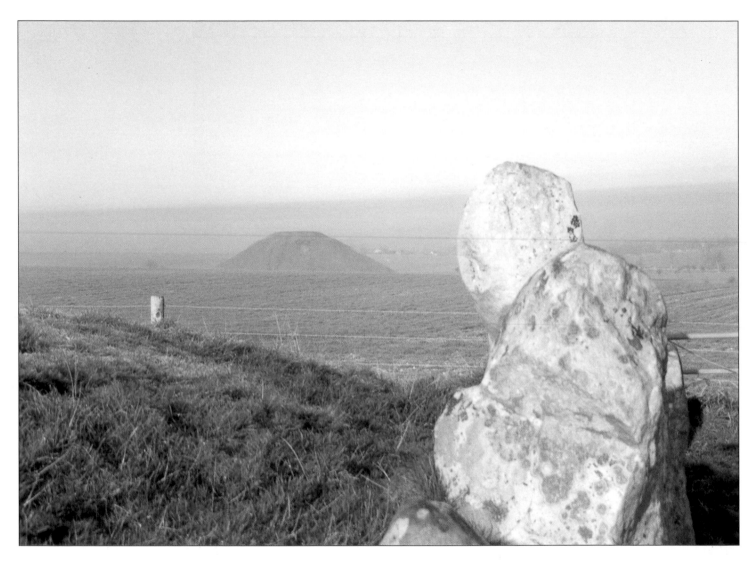

Looking towards Silbury Hill.
View from West Kennet Long Barrow. Wiltshire.

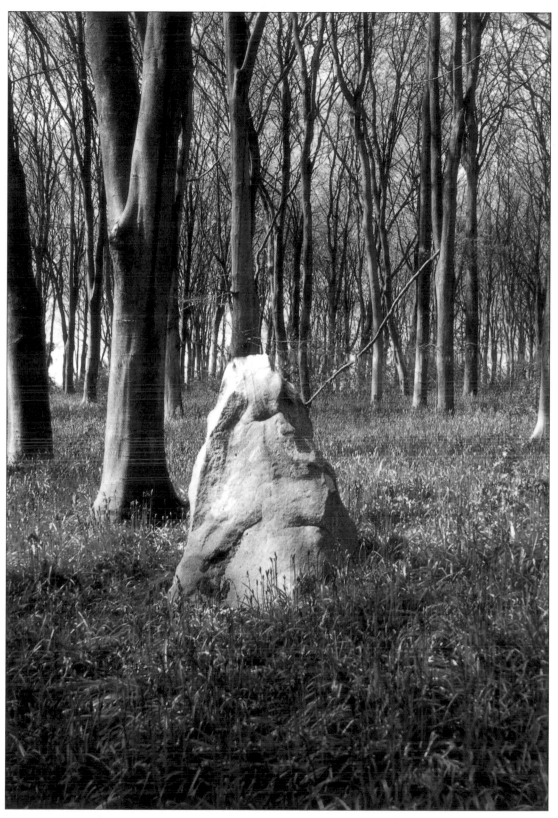

All alone.
Westwood, Wiltshire.

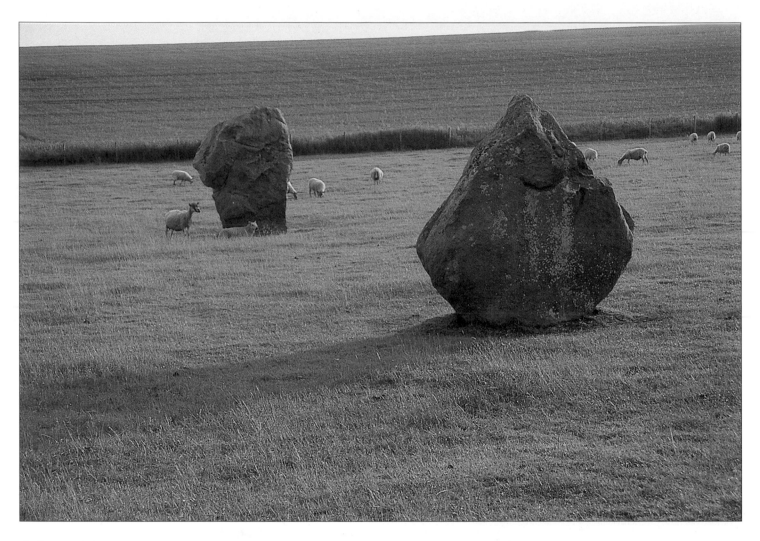

Jolly rustics.
The Avenue, Avebury, Wiltshire.

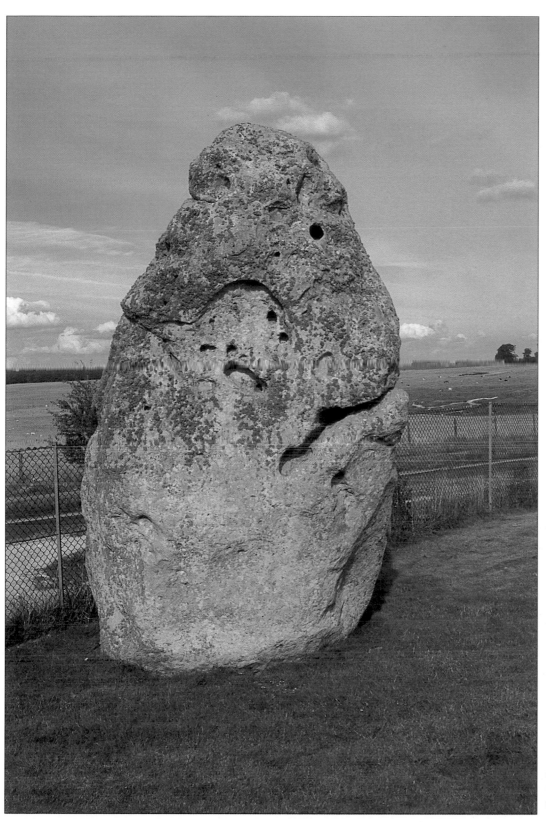

Down in the dumps.
Heelstone. Stonehenge,
Wiltshire.

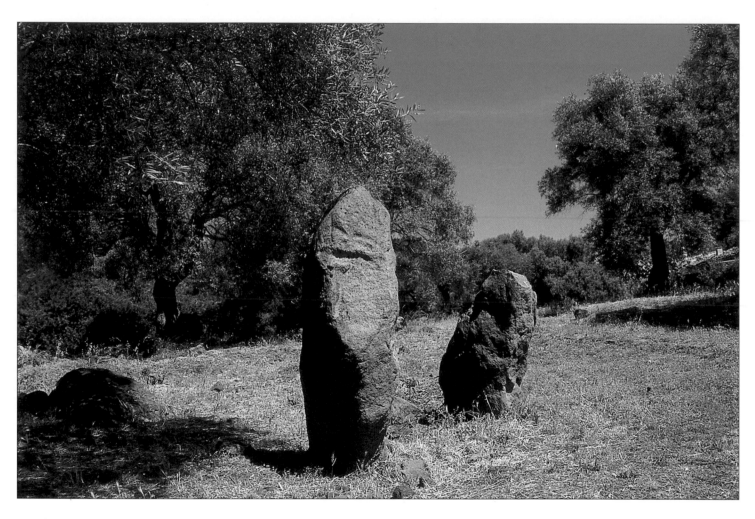

Native gnomes.
Two menhirs near a holy well at the Temple of Santa Christina, Sardinia.

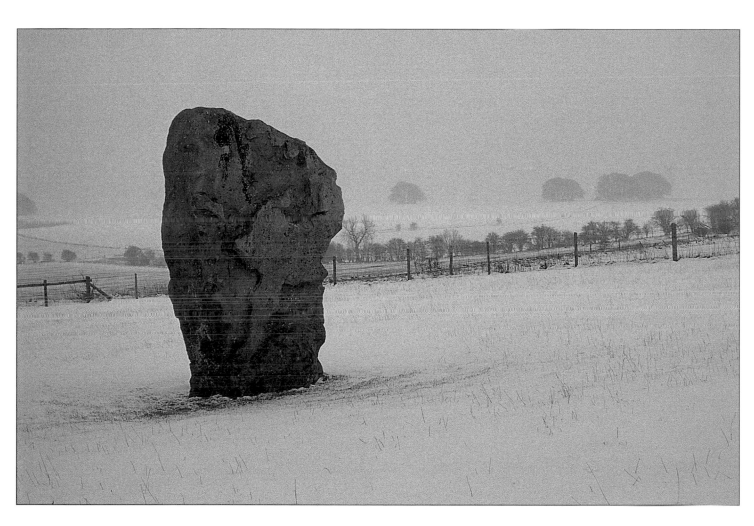

Silent witness.
Avebury Avenue, Wiltshire.

Good morning!
Alton Barnes,
Wiltshire

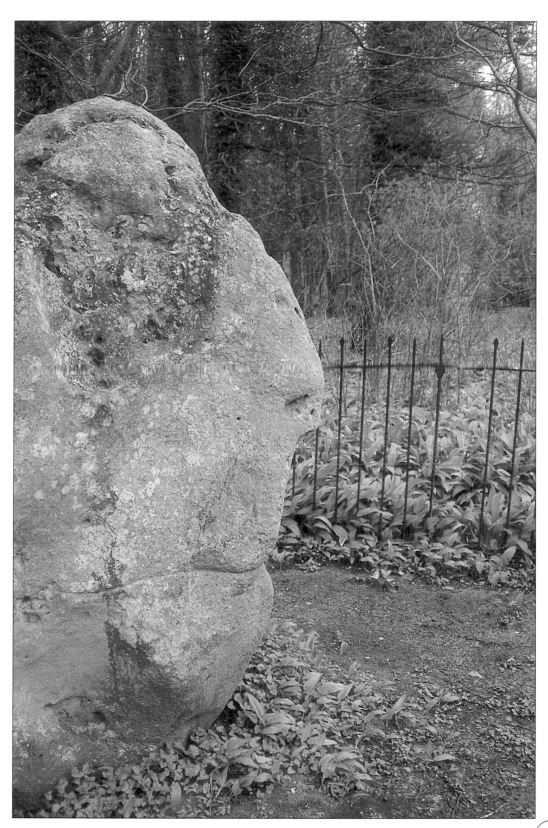

Fenced in.
One of the Four Stones,
a stone circle near
Dorchester, Dorset.

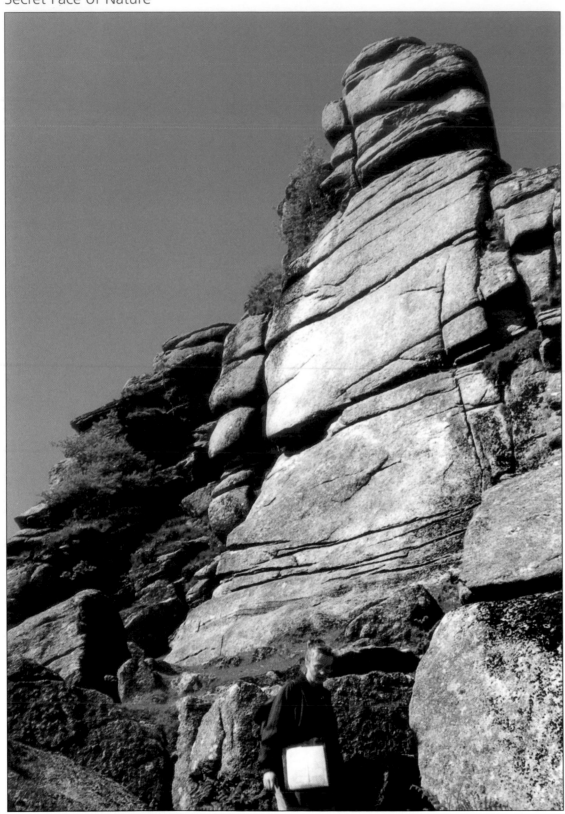

Rock giant.
Vixen Tor, Dartmoor,
Devon.

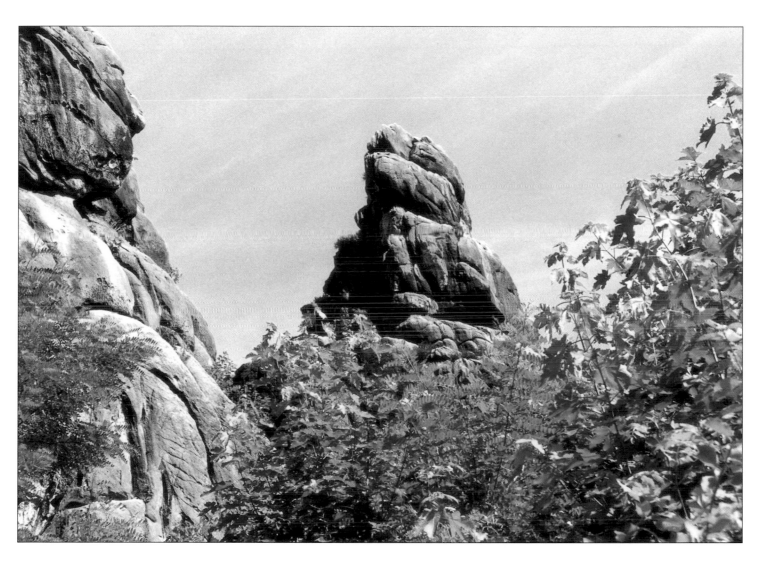

Extern Stones.
In the Teutoburger Forest, near a lake in the midst of wooded hills, this
sacred place has been revered for thousands of years, Westphalia, Germany.

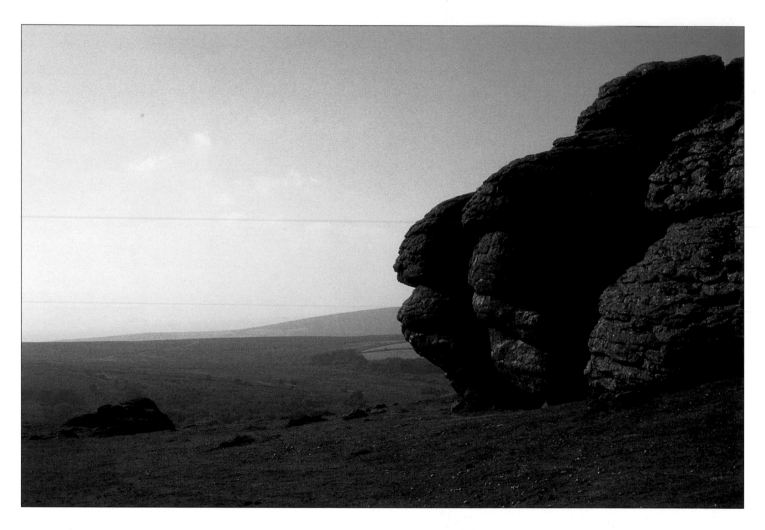

Emerging types.
Saddle Tor, Dartmoor, Devon.

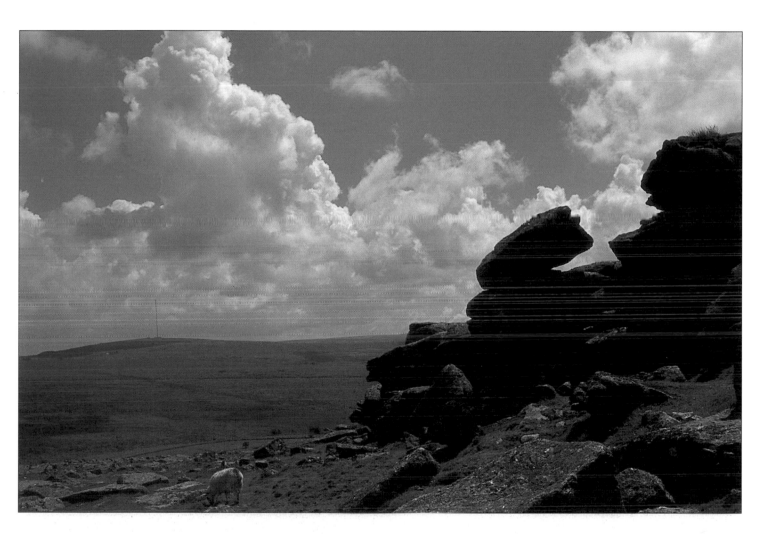

Dialogue in rock.
Little Staple Tor, Dartmoor, Devon.

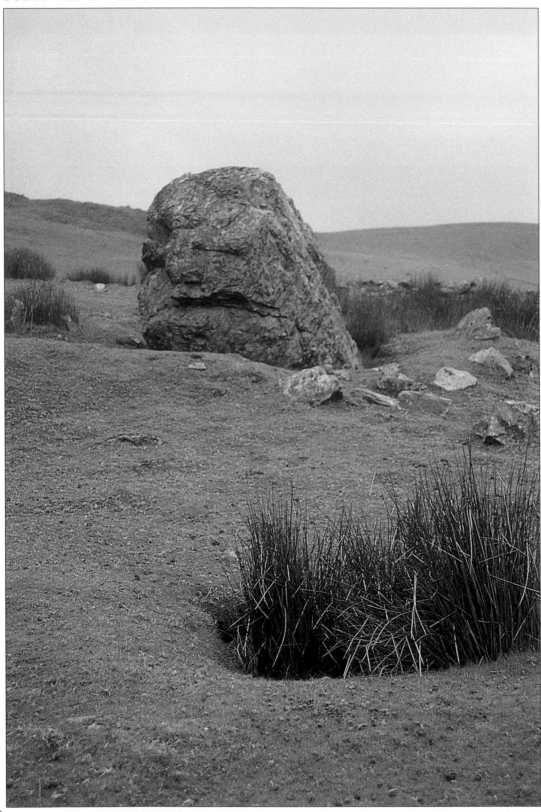

The grimace.
Northern coast of
North Uist, Outer
Hebrides, Scotland.

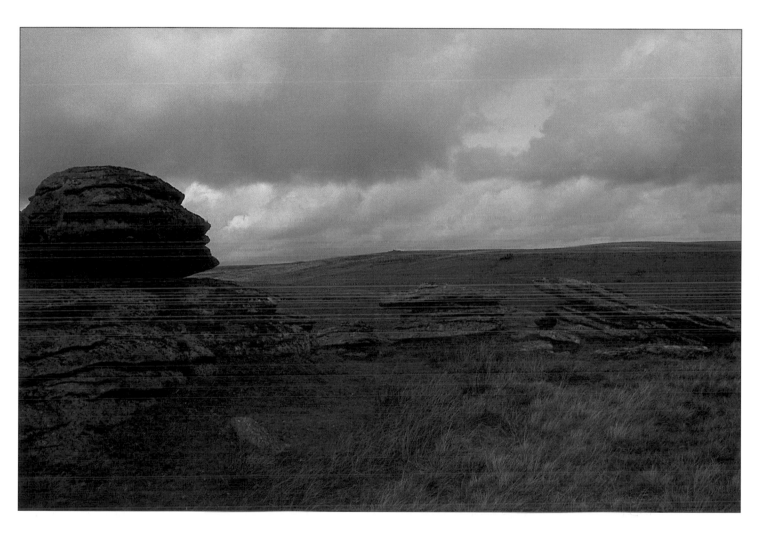

The idealist.
Beardown Tors, Dartmoor, Devon.

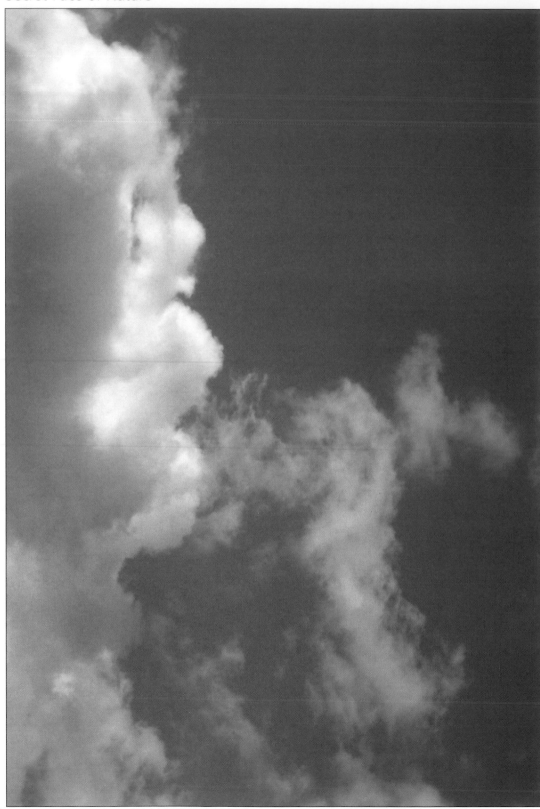

Smouldering beauty.

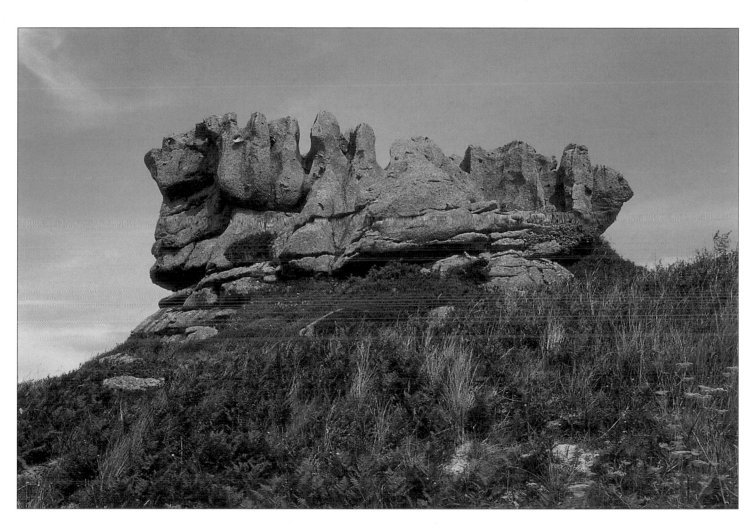

The crown.
Britanny, France.

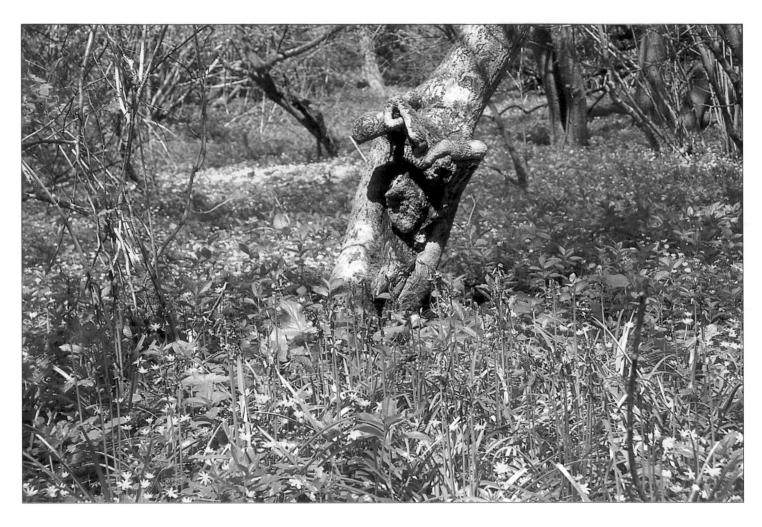

Woodland creatures.
Gopher Wood, near Huish, Vale of Pewsey, Wiltshire.

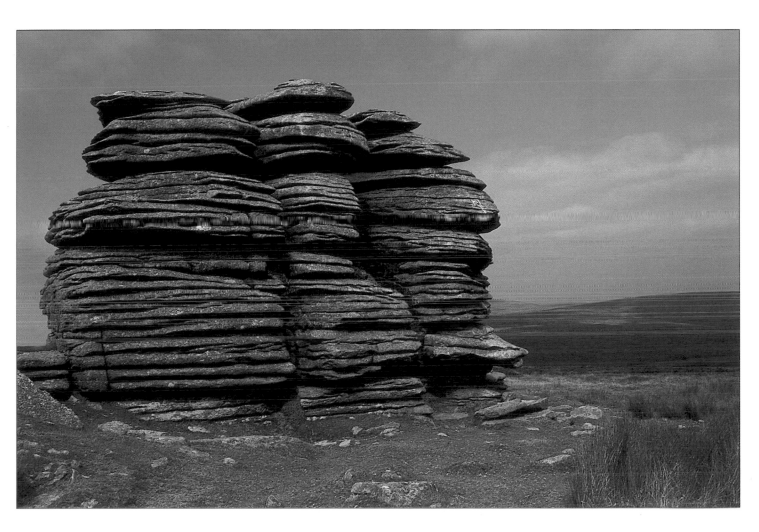

Pile of plates.
Watern Tor, Northern Dartmoor, Devon.

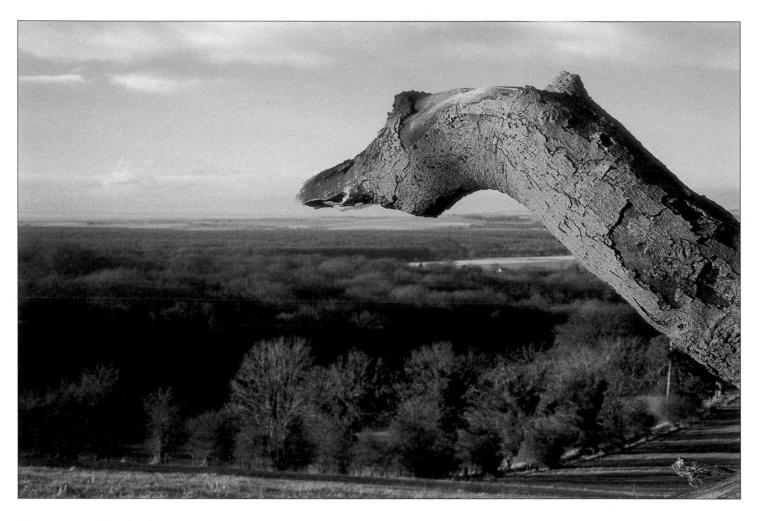

Dragon on the lookout.
Martinsell Hillfort, Wiltshire.

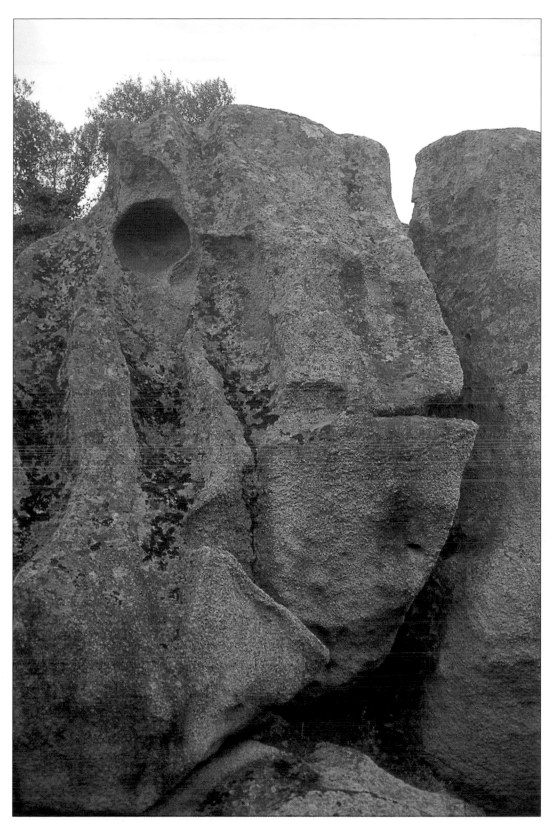

The whisper.
Mountains of Northeast Sardinia.

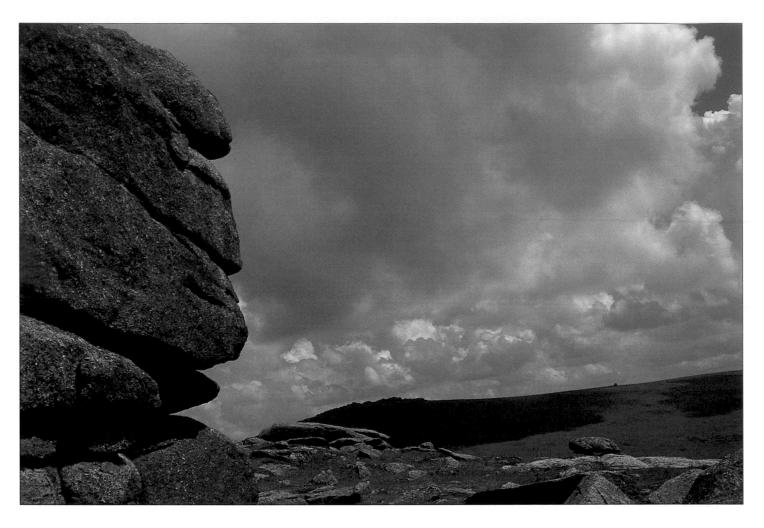

Grim guardian.
Winter Tor, Dartmoor, Devon.

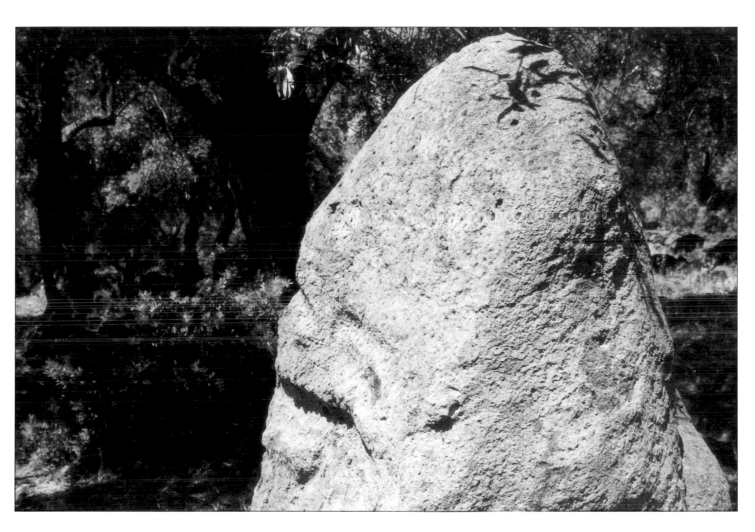

Small menhir in rainforest.
Near Tikal, the great Mayan city, Guatemala.

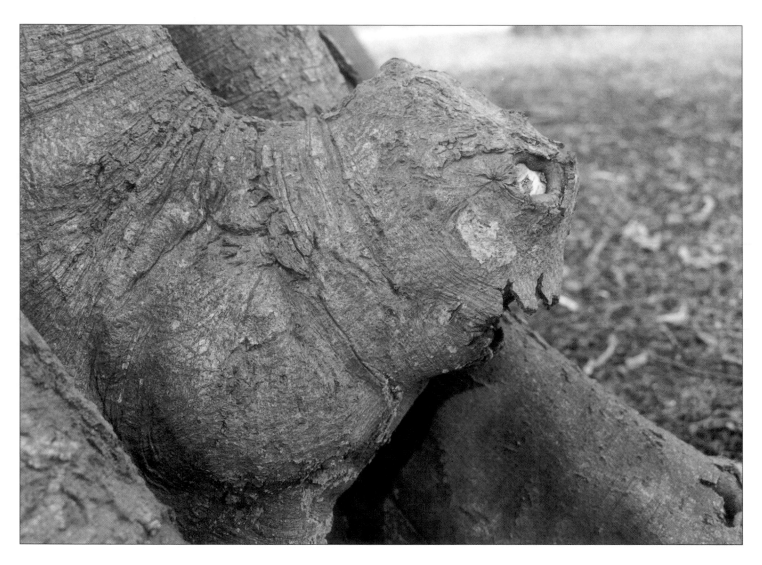

Tree spirit.
In the wooded hills, Eifel, near Cologne, Germany

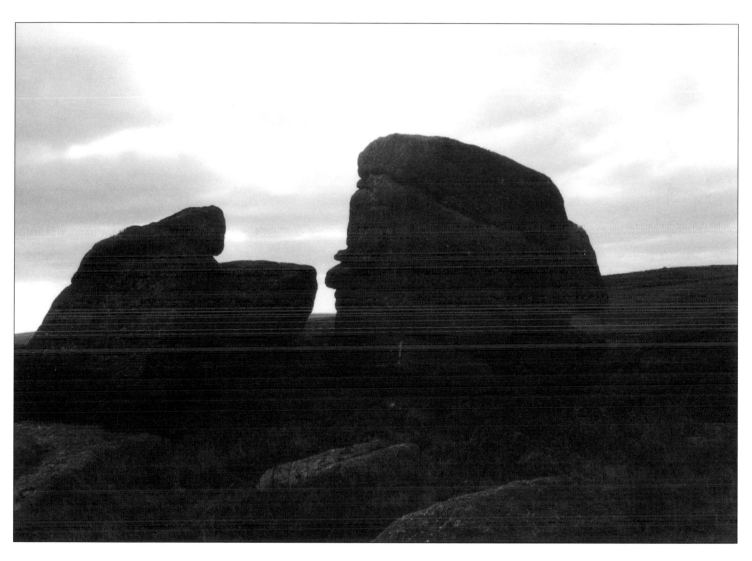

Moody moorland.
Carn Galver moorland, near Lower Porthmeor, Land's End, Cornwall.

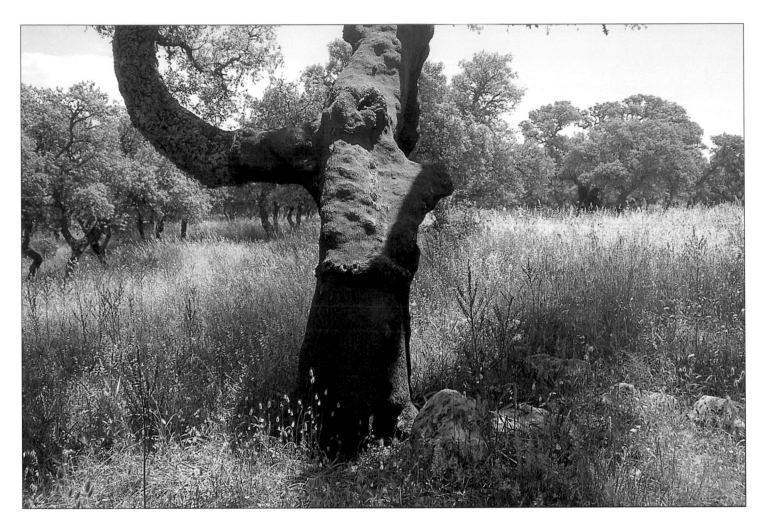

A graceful figure.
Central Sardinia.

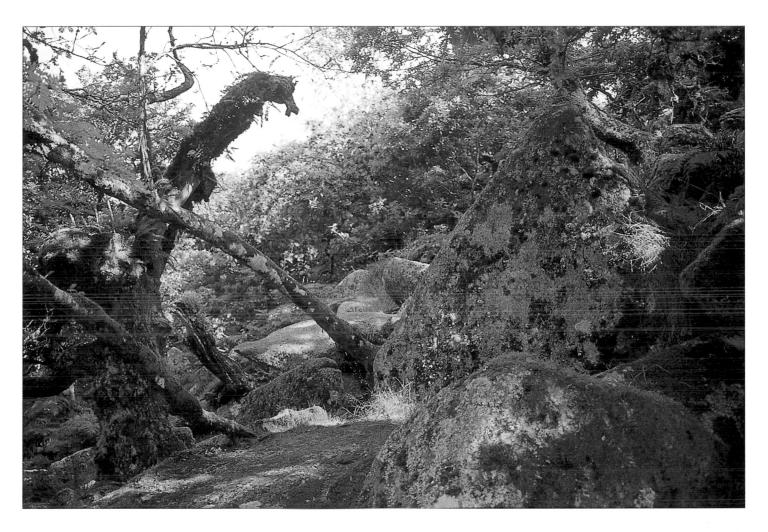

A seahorse in the wood.

Wistman's Wood, Dartmoor, an ancient colony of gnarled and stunted oaks, last survivors of the indigenous woodland of the moor, growing out of a clitter of granite boulders. Said to be a sacred grove where Druids worshipped, other legends connect the wood with the Wish Hounds, dreaded demons who terrorise the moor after midnight. During the day, a site of special scientific interest.

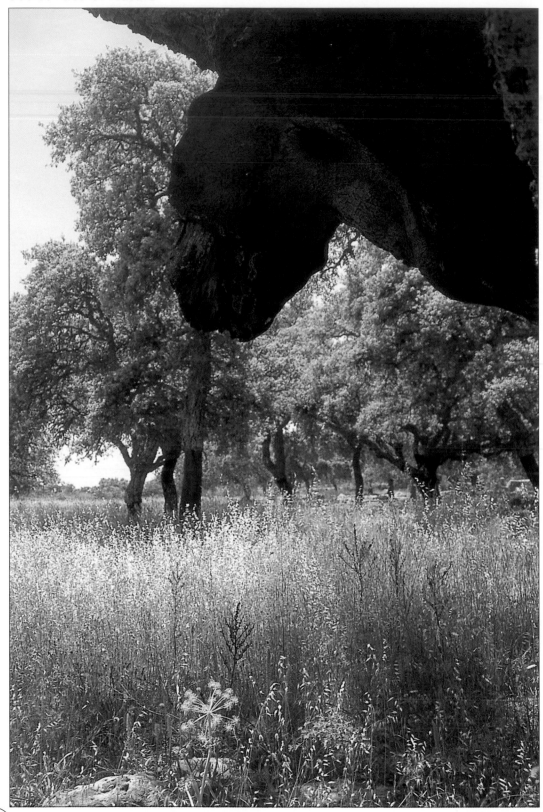

Orang-utang.
Cork oak, Sardinia.

Goblin's lair.
Sweet chestnut tree, Wiltshire.

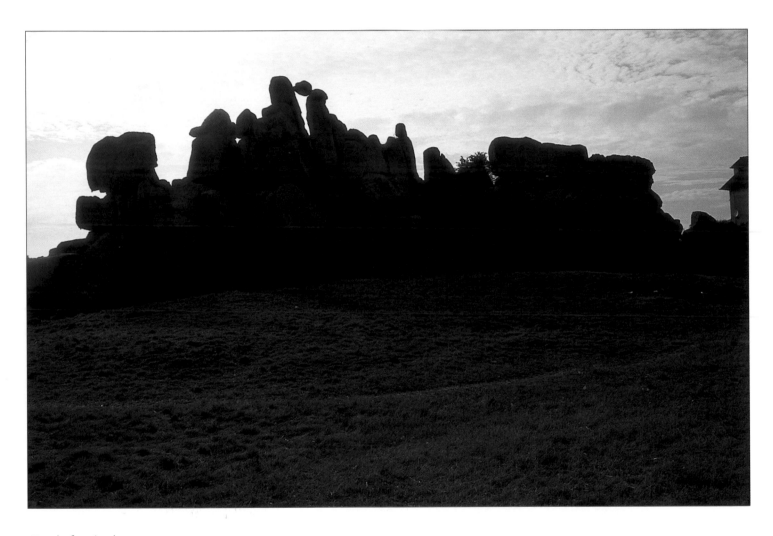

Rock festival.
Britanny, France.

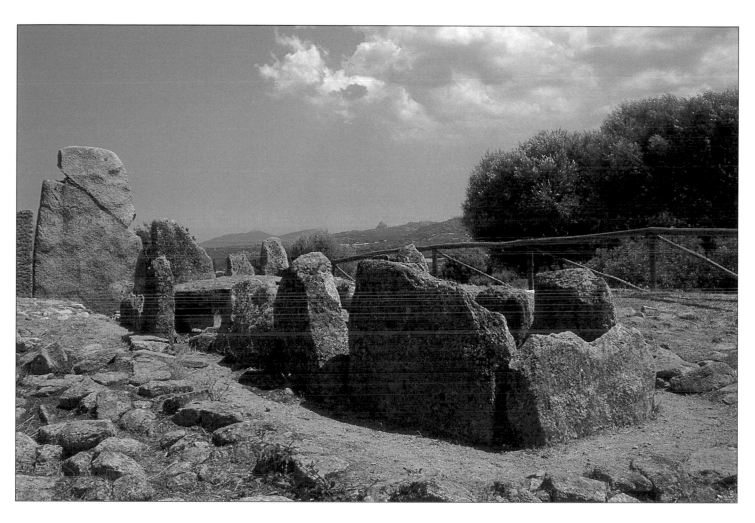

Custodian of the tomb.
Prehistoric long barrow, Arzachena, Sardinia.

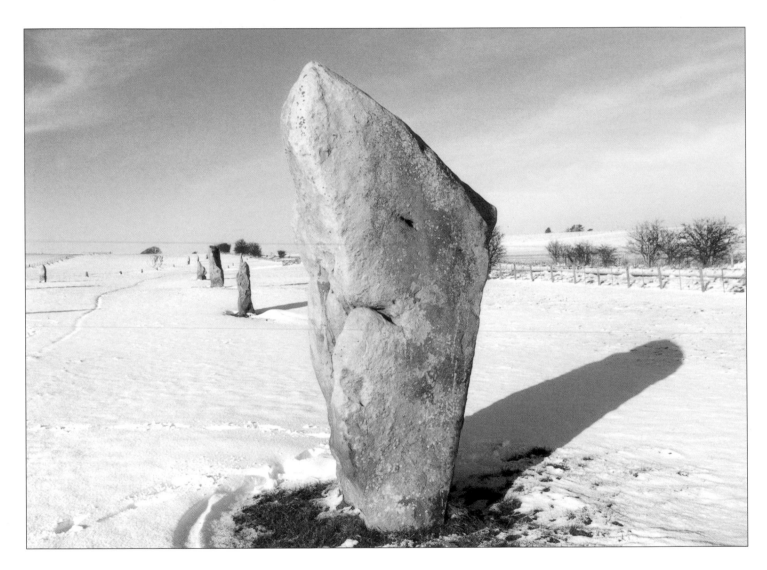

Shark.
Avebury Avenue, Wiltshire. A similarity to General de Gaulle has been noted.

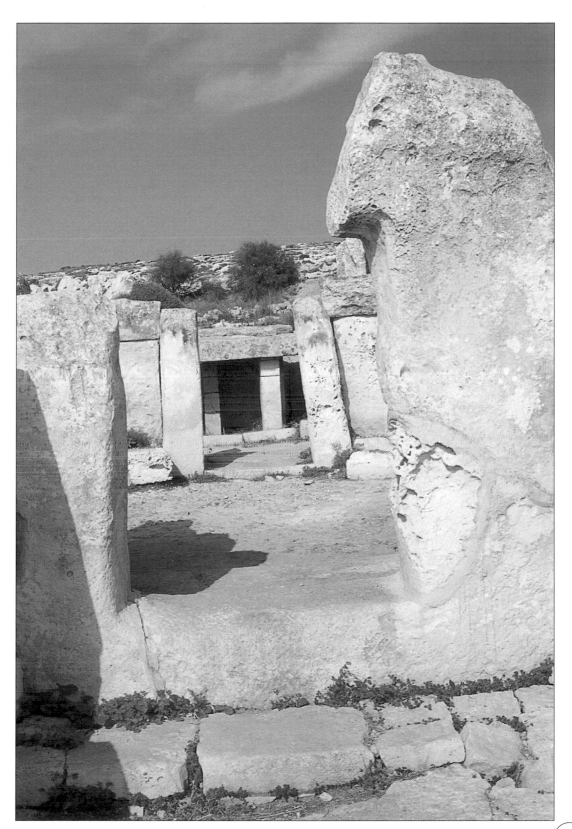

Sentry at the gate.
Mnajdra Temple, Malta.

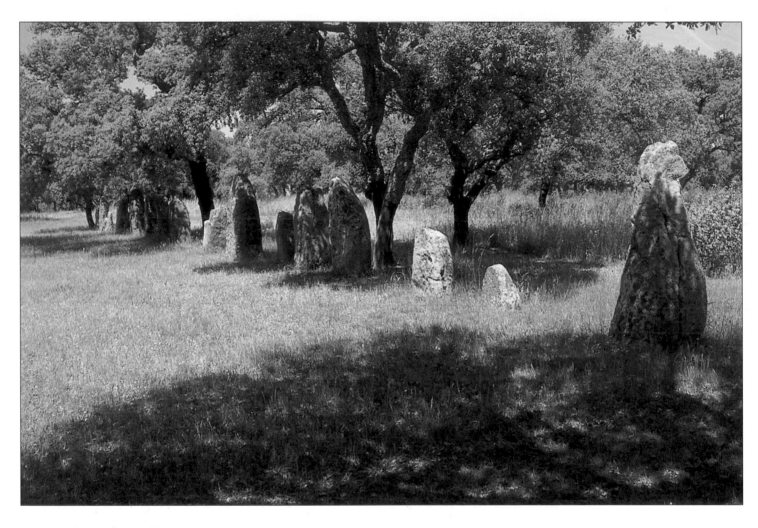

Procession of menhirs.
Pranu Mutteddu Necropolis, at the top of a mountain plateau, Sardinia.

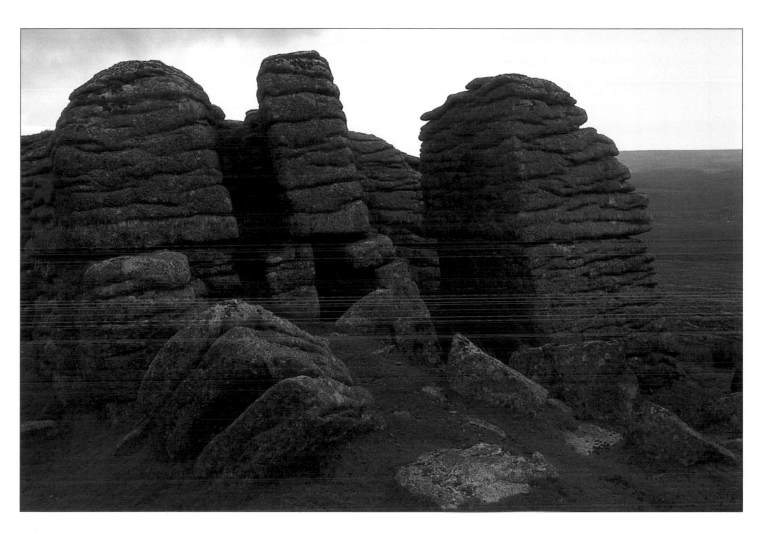

The dwellings.
Oke Tor, Dartmoor, Devon.

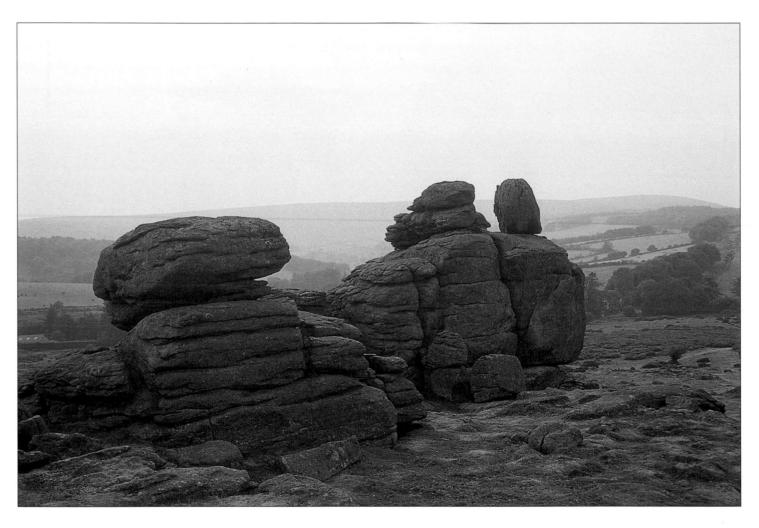

The rocky marriage.
Hound Tor, Dartmoor, Devon.

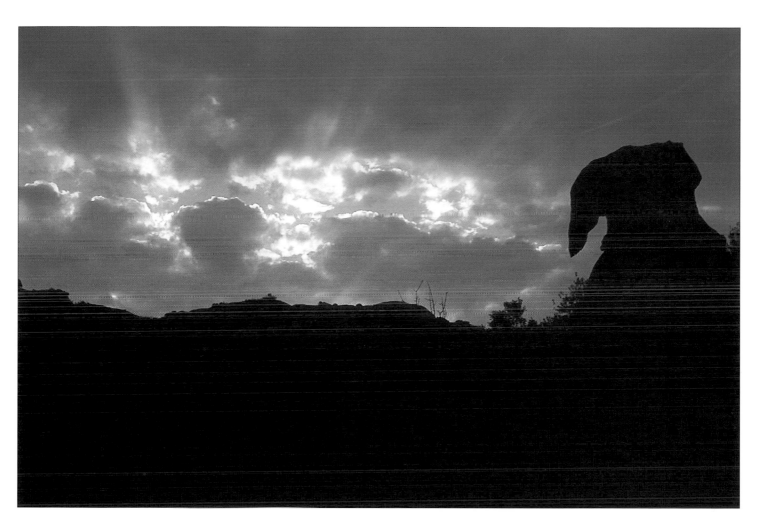

Nightcap.
In the mountains near Malchittu, Sardinia.

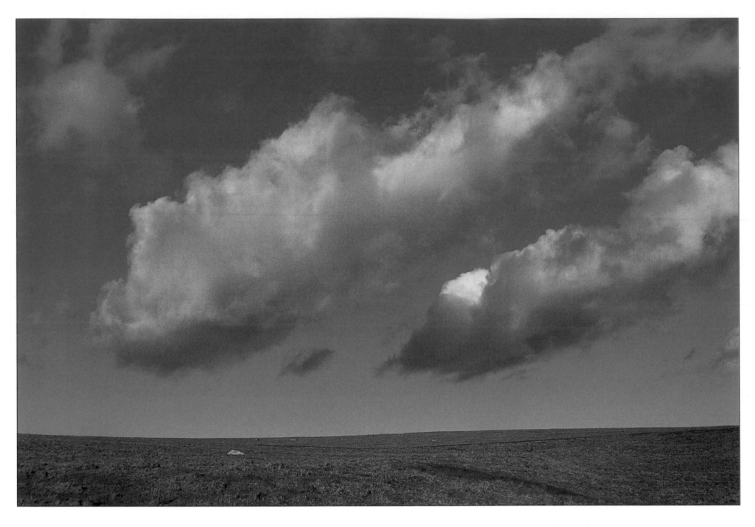

Diving down.
Over Fyfield, Marlborough Downs, Wiltshire.

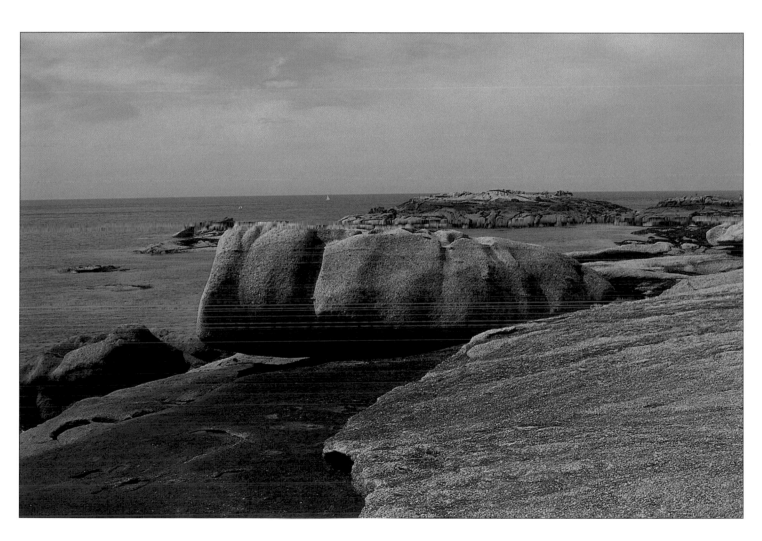

Cast ashore.
Coast of Britanny, France.

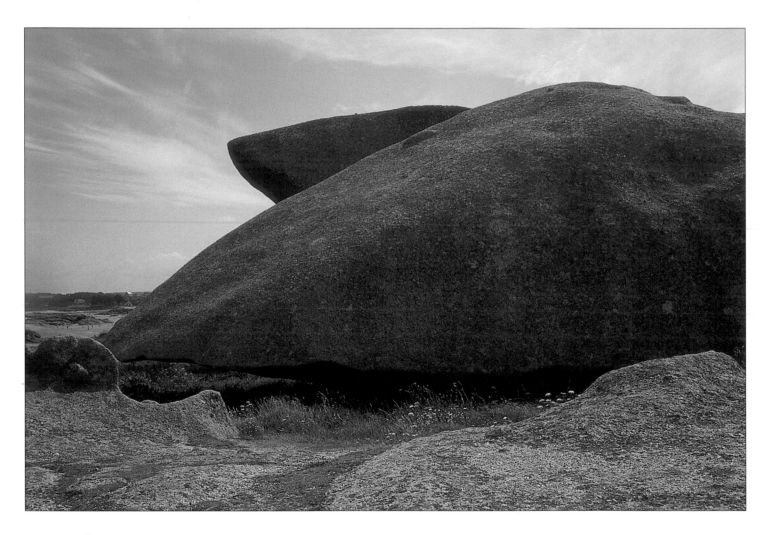

Stranded.
Britanny, France.

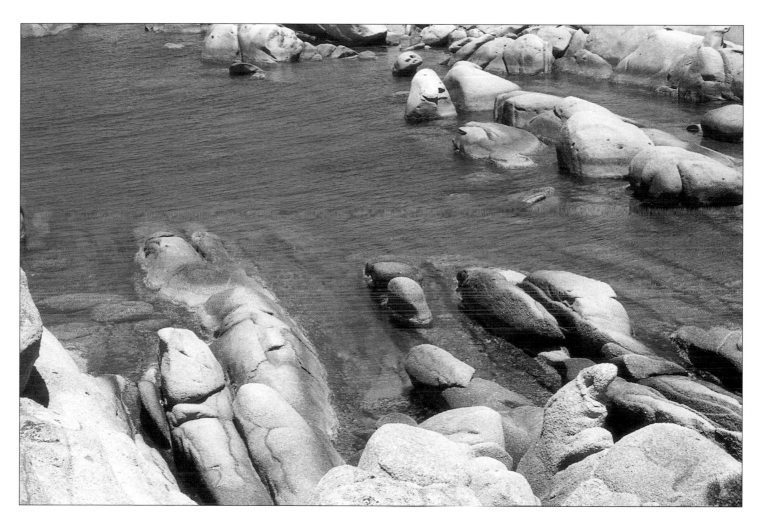

Bathing beauties.
Capo Testa, Sardinia.

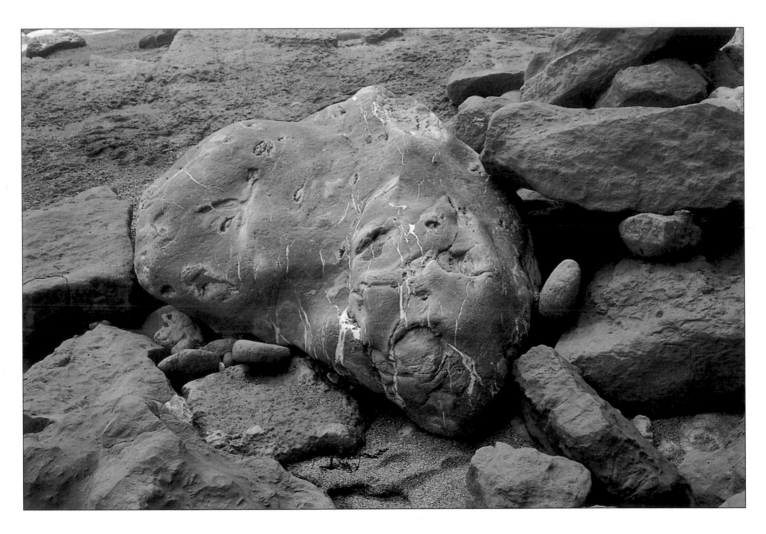

On the rocks.
Chesil Beach, near Burton Bradstock, Dorset.

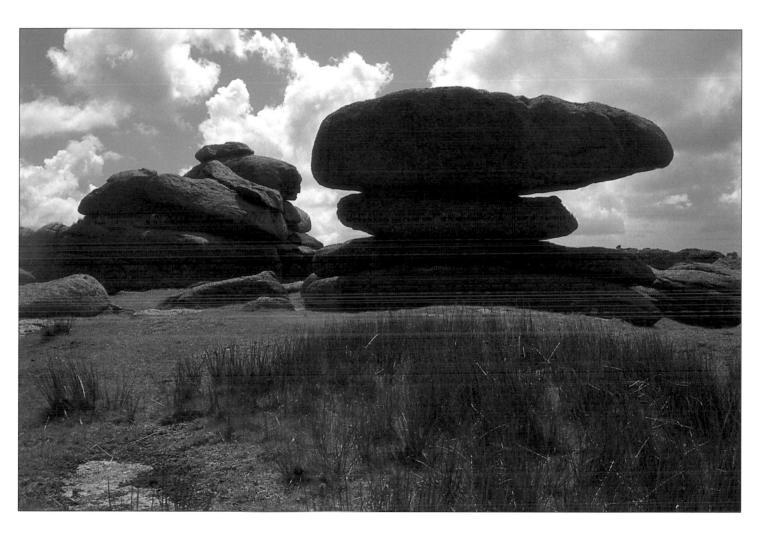

Companionship.
Roos Tor, Dartmoor, Devon.

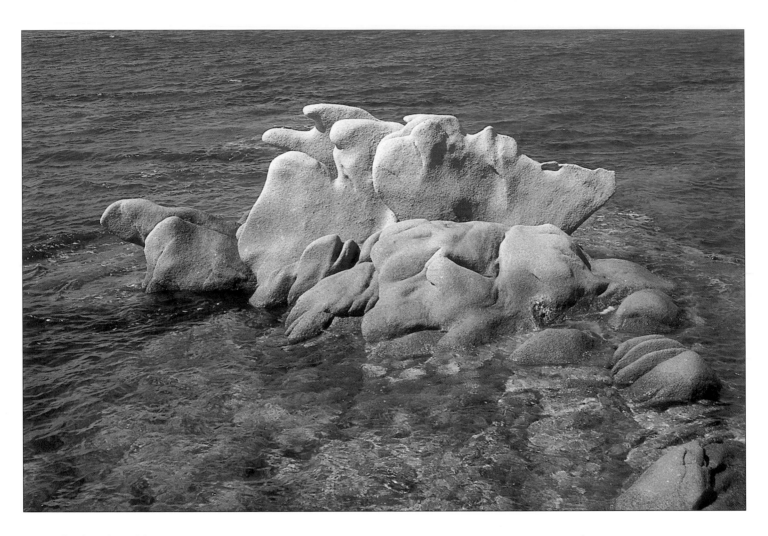

Caught by the tide.
Costa Smeralda, Sardinia.

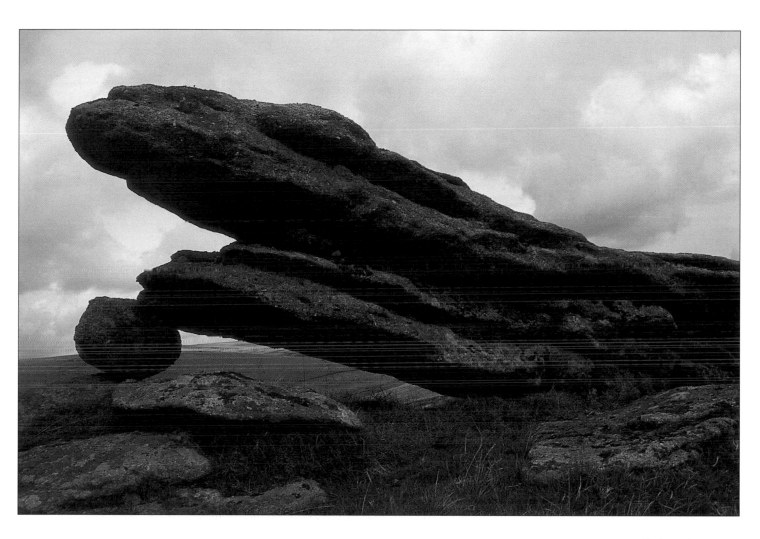

Balancing act.
Lydford Tor, Dartmoor, Devon.

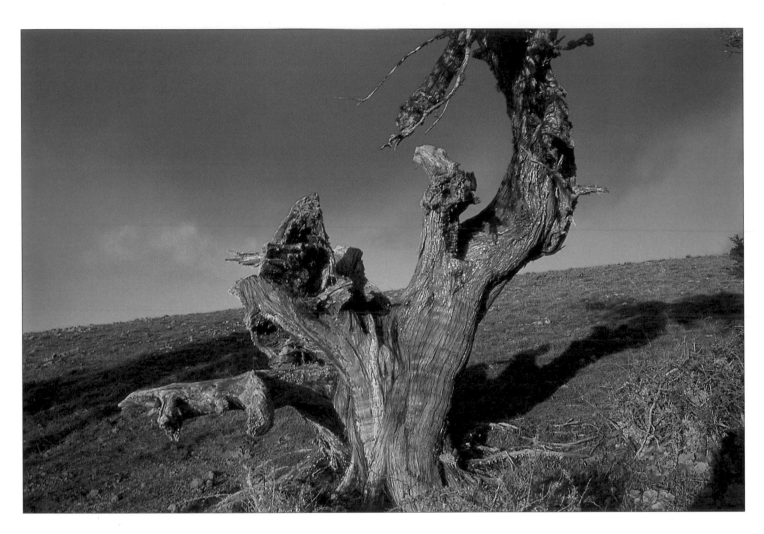

Senility.
Western El Hierro, Canary islands.

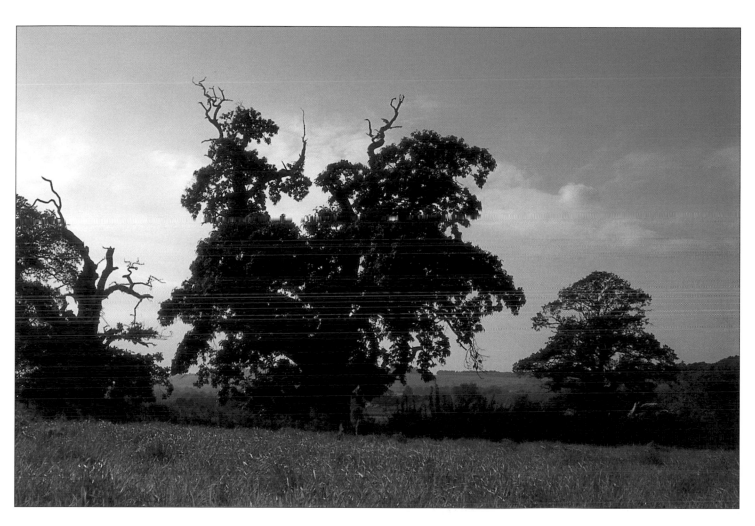

Dance macabre.
Sweet chestnut trees, Wiltshire.

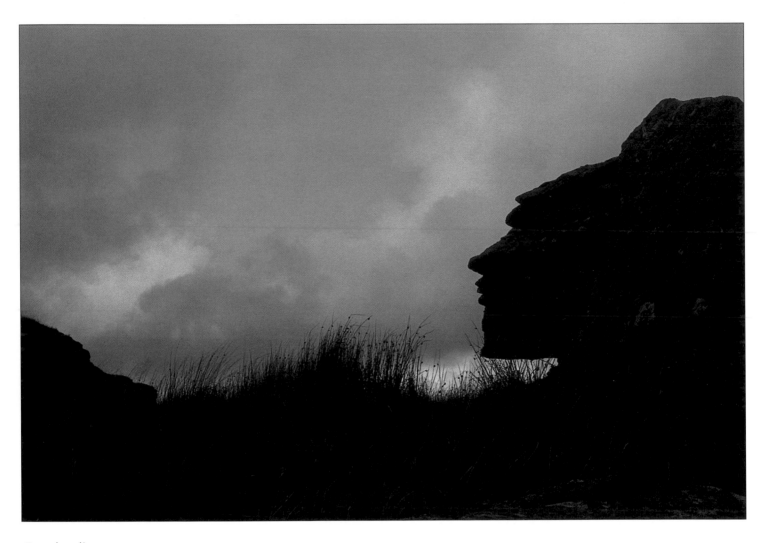

Foreboding.
Laughter Tor, Dartmoor, Devon.

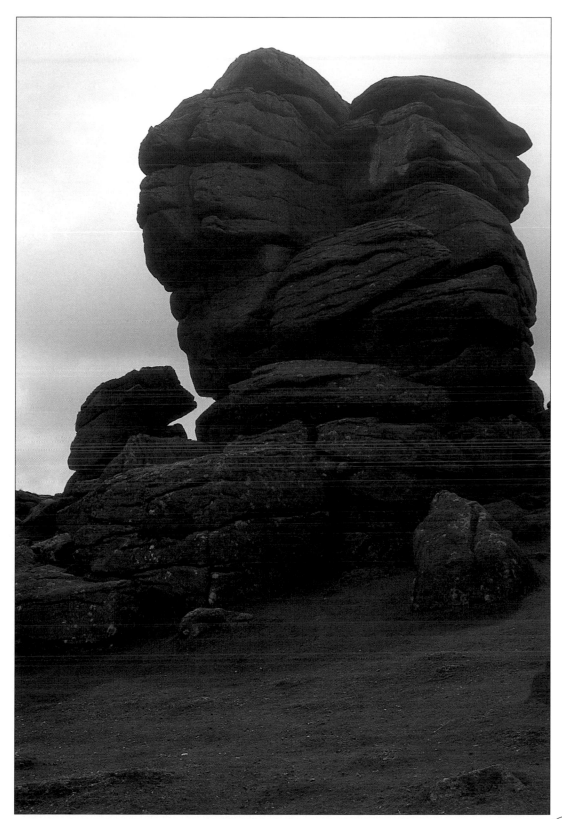

Who put them there and why?
Vixen Tor, a prominent landmark connected with many, mostly dark legends. One is about Vixana who lured travellers into the bog below the rock. Dartmoor, Devon.

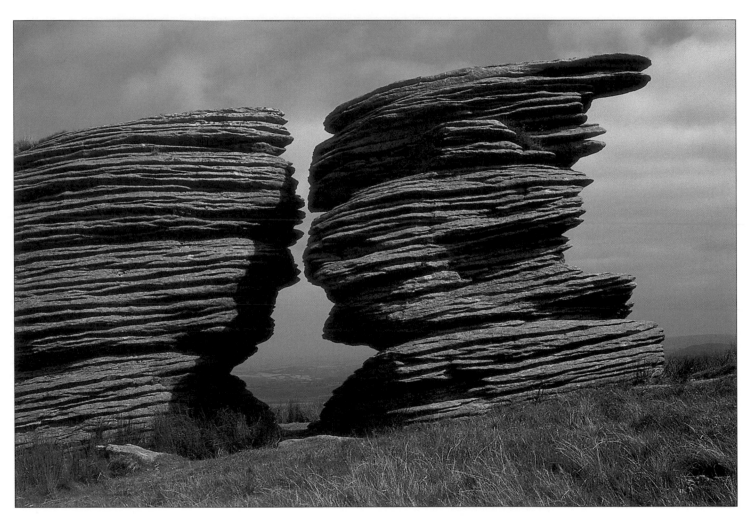

Face to face.
Watern Tor, Dartmoor, Devon.

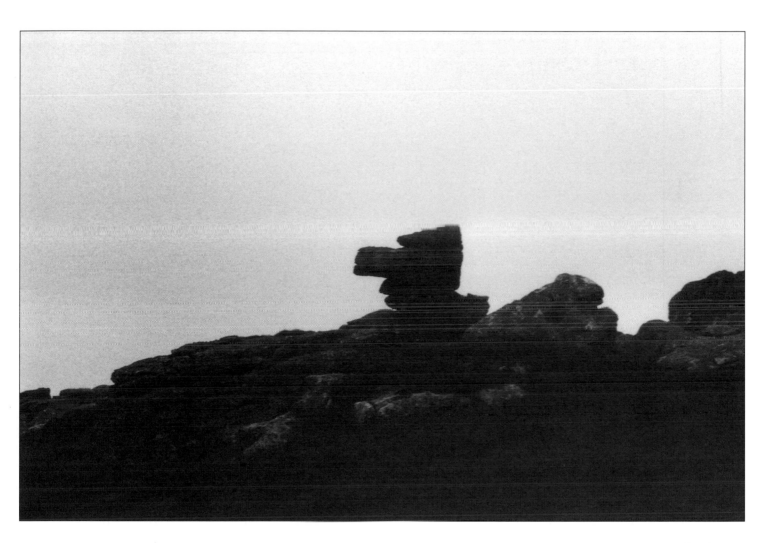

Andy Capp.
Carn Kenidjack, near St Just, Land's End, Cornwall.

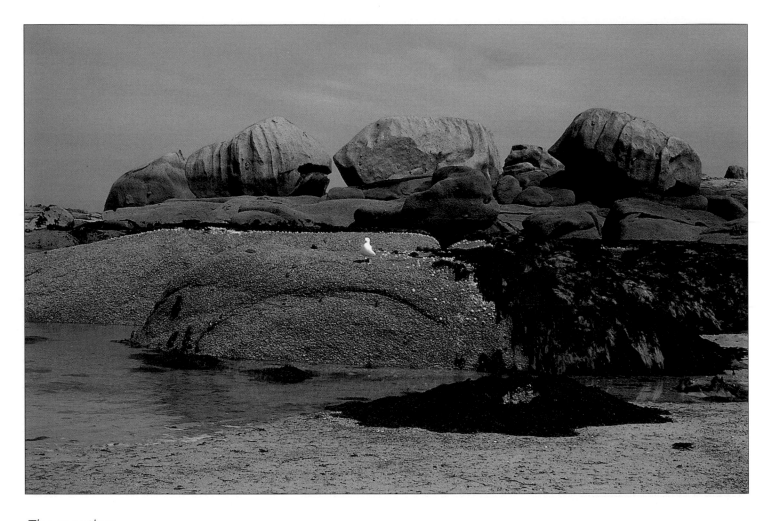

The meeting.
Britanny, France.

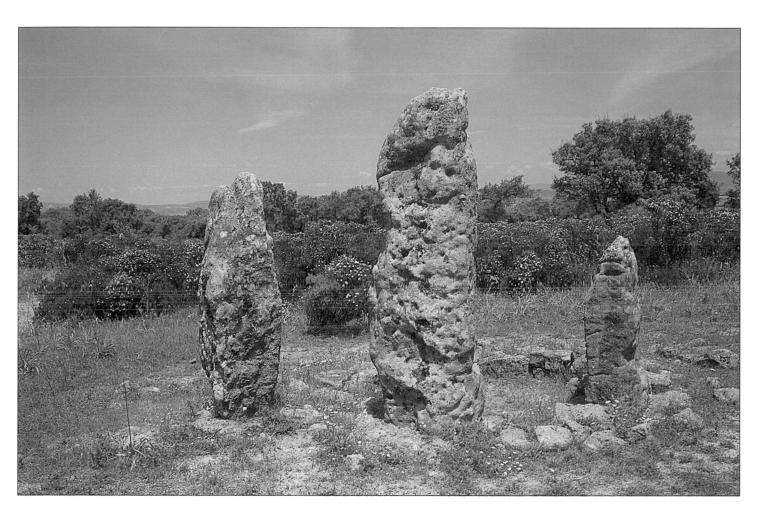

Masks.
Near the Pranu Mutteddu Necropolis, an important sacred site in the mountains of central Sardinia.

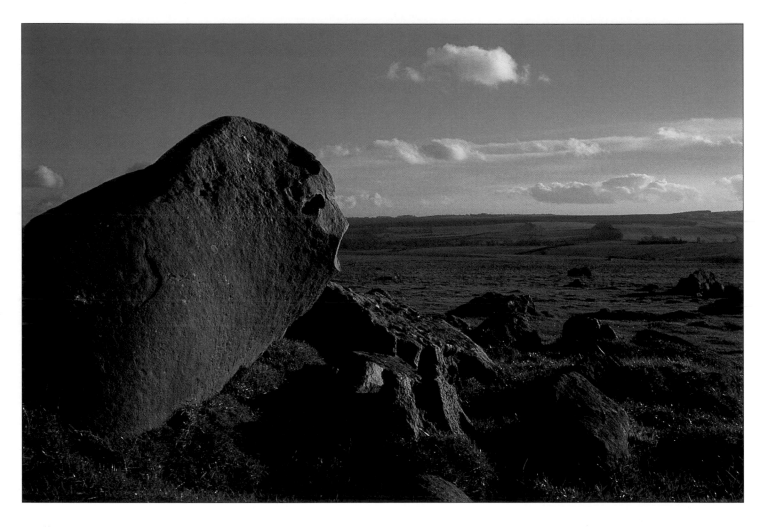

Calling out.
Fyfield Nature Reserve, near Marlborough, Wiltshire.

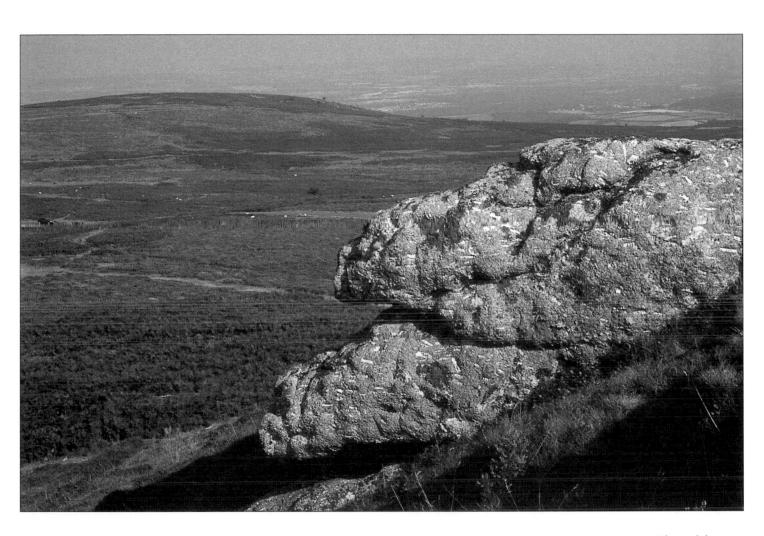

The old one.
Hay Tor, Dartmoor, Devon.

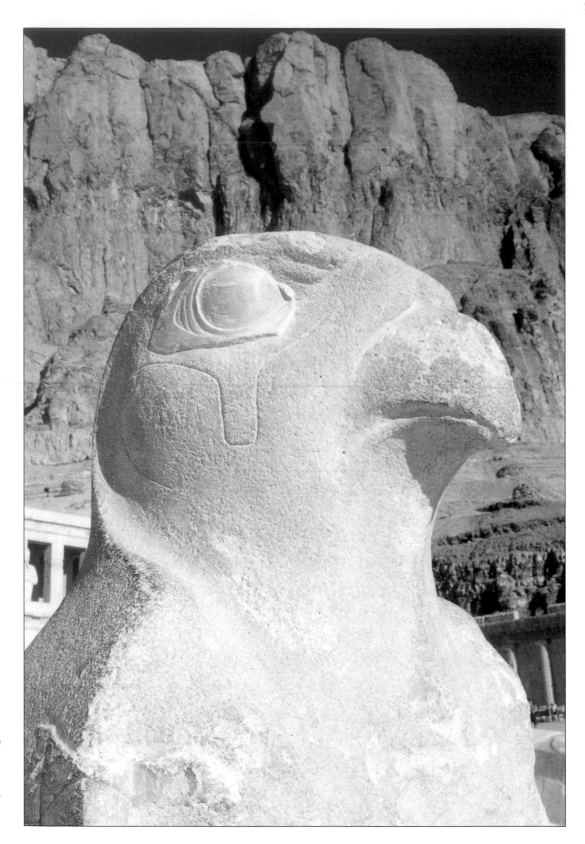

Above the statue of Horus.
Temple of Hatshepsut, West bank, near Luxor, Egypt.

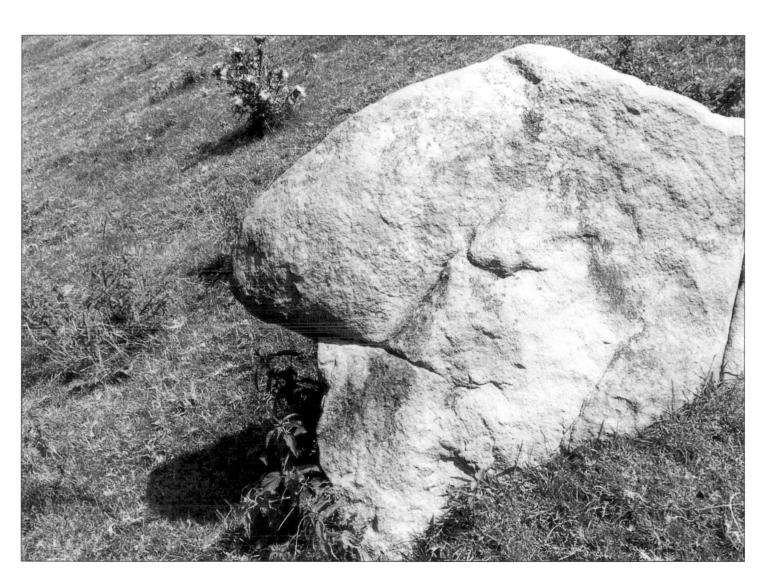

Grumpy
Mendip Hills, Somerset.

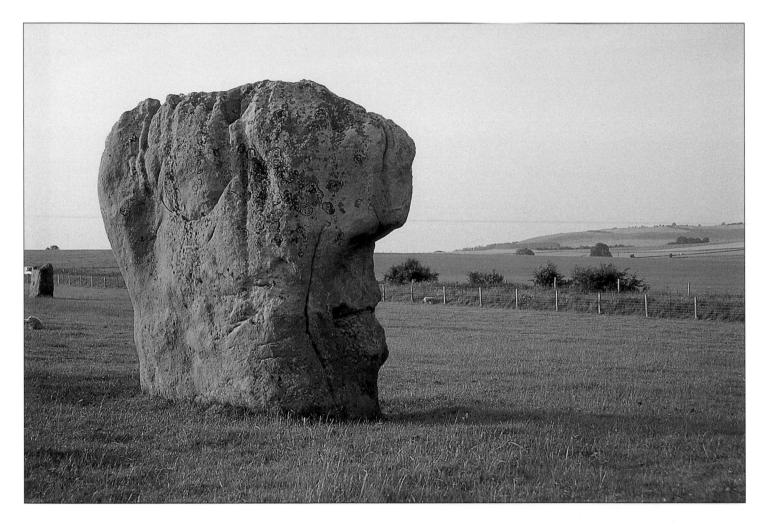

Under the weather.
Avebury Avenue, Wiltshire.

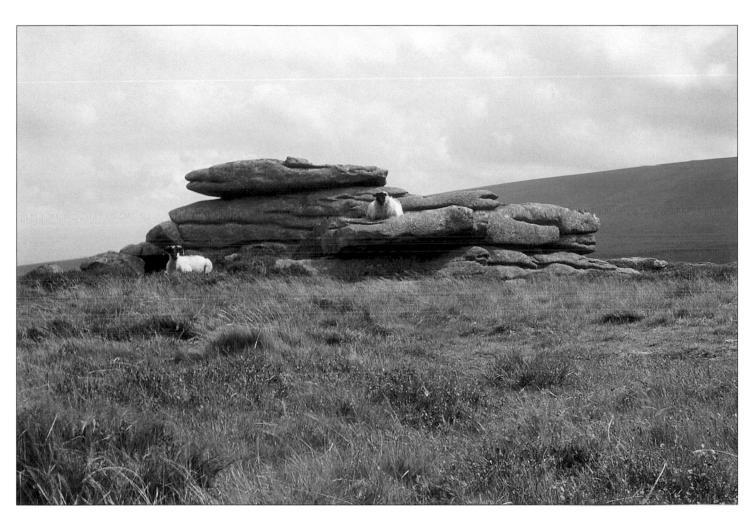

Togetherness.
Higher Tor, Dartmoor, Devon.

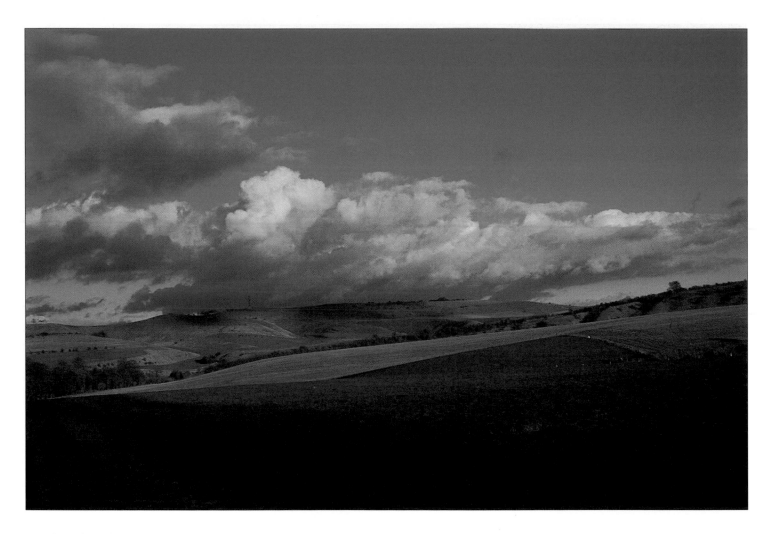

In the clouds.
Over Oldbury Castle, Cherhill, Wiltshire.

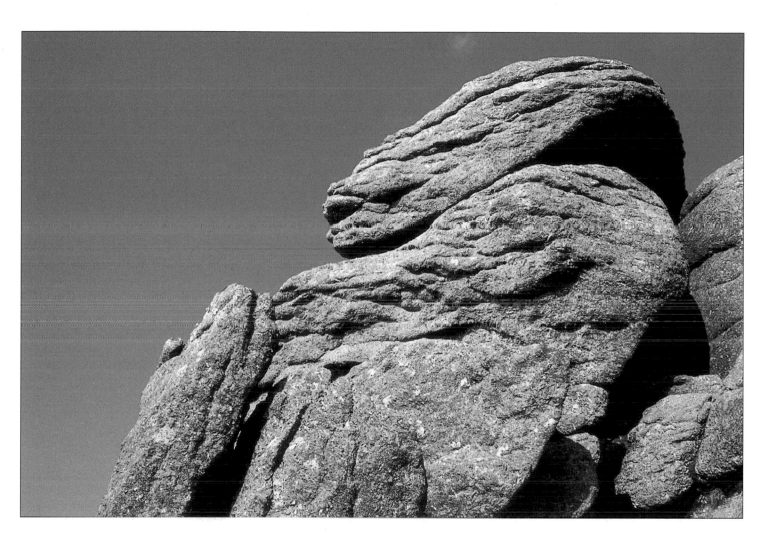

Composition.
Saddle Tor, Dartmoor, Devon.

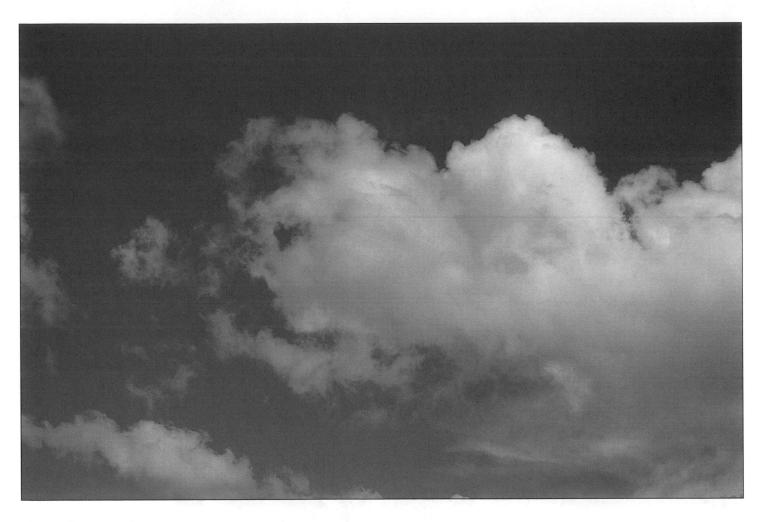

A passing angel.

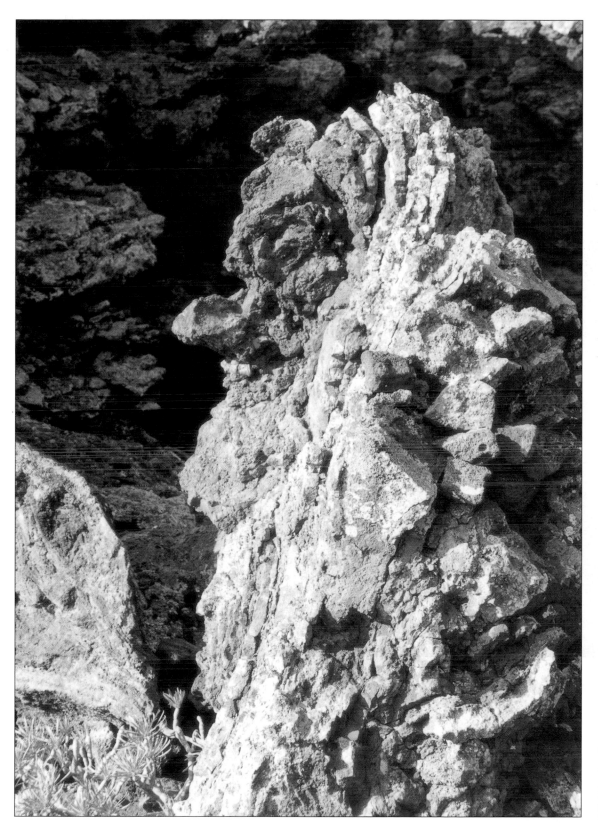

Witch.
Volcanic rock,
El Hierro, Canary
Islands.

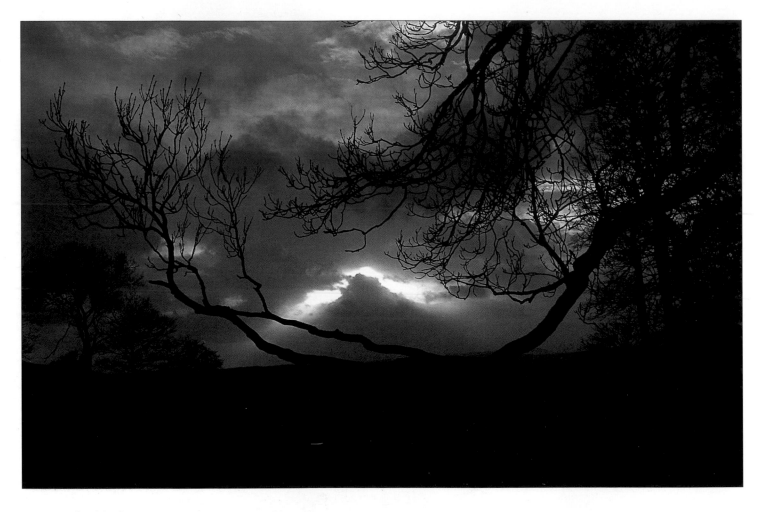

Pyramid of light.
Chalice Hill, Glastonbury, Somerset.